ABANDONED DELMARVA

THE FORGOTTEN PLACES OF THE DELMARVA PENINSULA

TODD M. DALGLIESH

AMERICA
THROUGH TIME®
ADDING COLOR TO AMERICAN HISTORY

America Through Time is an imprint of Fonthill Media LLC
www.through-time.com
office@through-time.com

Published by Arcadia Publishing by arrangement with Fonthill Media LLC
For all general information, please contact Arcadia Publishing:
Telephone: 843-853-2070
Fax: 843-853-0044
E-mail: sales@arcadiapublishing.com
For customer service and orders:
Toll-Free 1-888-313-2665

www.arcadiapublishing.com

First published 2021

Copyright © Todd M. Dalgliesh 2021

ISBN 978-1-63499-335-7

Typeset in Trade Gothic 10pt on 15pt
Printed and bound in England

CONTENTS

ABOUT THE AUTHOR

TODD DALGLIESH is a photographer based out of Baltimore, Maryland. He works in multiple fields of photography but has long had a passion for photographing abandoned places. Now, fifteen years after he was first inspired by an impromptu adventure into an abandoned home, he is continuing his journey in photography as he explores the world of abandoned structures. Todd is constantly traveling the U.S. in search of places to document, and the list of locations is ever growing, along with his drive for photographing and preserving these abandoned places.

INTRODUCTION

My name is Todd Dalgliesh, and I am a photographer based out of Baltimore, Maryland. Exploring the abandoned started a good while back for me. I can always recall my mother being the curious type and peering in vacant houses out in the woods near where I grew up. However, the first true exploration that set it off happened when I was thirteen. Visiting a friend for a sleepover one night, we grew bored of playing video games and sifting through movies to watch. My friend looked over to me and said, "Well, there is this abandoned house up the street." I was interested, as any thirteen-year-old boy would be, just for the fact that it was something "creepy" to get myself into. He continued, "The kids at my school say you have to get in through the cellar door," and off we were. I can recall the feeling of uncertainty, a little bit of fear, and a ton of excitement. Through the cellar door and up the stairs to the living room, I can still see it vividly. The room was set with an old Victorian-era armchair, an oval red and brown carpet, and a child's photo on the mantel. Exploring the whole house, the only other thing left behind was an old piano that I played a few notes on. That night would spark something in me that I could not have expected.

I spent the next few days tracking down abandoned places to explore, and as I went through these websites, I noticed a small number of people creating beautiful images in the spaces and I was inspired. I got my hands on the first camera I could and began shooting. Over the first few years I developed a huge interest in photography even beyond abandoned places. I ended up taking college photography courses that taught me how to handle and produce images I wanted, learning analog and digital alongside each other. Those years in school taught me more about photography than I would have ever imagined, and I am grateful I was able

to attend. At the time of writing this publication, I am twenty-seven years of age, and I'll tell you I've spent very few weeks without at least one exploration since the age of thirteen. I am always on the hunt for new places to photograph, new places to learn the history of, and new ways to make my photographs more interesting. Photography has long been my escape from the mundane of day-to-day rituals and will always be my passion. It is a tool of the imagination, a way of expressing a view that is otherwise left up to verbal translation. In abandoned and vacant locations where all falls silent, it's all about the feel of a space, and the way the light plays. I release the shutter, and what falls between the camera and location is the art. When photographing, I capture more than an image—I capture moments in time. We all interpret scenes and situations differently; this is my interpretation.

1

TOME SCHOOL FOR BOYS

The well-known and historic Tome School for Boys sits on top of a cliffside that runs along the Susquehanna River. Looming over the small town of Port Deposit, its large structures somehow manage to hide themselves behind the tree line from any visitors down below. This scenic and all-around wonderful campus was founded by a gentleman by the name of Jacob Tome, a well-known name in Maryland, Delaware, and Southern Pennsylvania. Jacob Tome was a philanthropist, a banker, and a politician. Unfortunately, Jacob Tome lost his life in Port Deposit, Maryland, to pneumonia when he was eighty-seven years old, but not before becoming one of the richest men of his generation. He invested in a lumber company and railroads and founded at least four banks. He was Cecil County's first millionaire and its greatest philanthropist, who gave money to colleges, churches, and schools, including the Tome School. He was a Republican and a supporter of Abraham Lincoln during the American Civil War. He was a member of the Maryland state senate in 1864. In 1871, he ran unsuccessfully for governor of Maryland. At the time of his death, he was in possession of $89,000,000, calculated to be around $2,735,148,000 today.

Tome, as a nonsectarian college preparatory school for boys, opened for boarders and received its first students in 1894. It was part of a system of schools that began with kindergarten, and taught through high school, that was collectively known as the Jacob Tome Institute. At the time of Jacob Tome's passing in 1898, he endowed the school such that in 1902 it is recorded to have owned both extensive buildings and to have a residual endowment of over $2 million. One of the results of the endowment was that between 1898 and 1902, the Jacob Tome School for Boys built a series of large granite buildings on the bluffs above Port Deposit, where it stands today.

Constructed in the style of Beaux-Arts, architects William Boring and Edward Lippincott Tilton designed these wonderful structures. The thirteen of those surviving buildings today include Memorial Hall, Jackson, Madison, and Harrison dormitories, the Chesapeake Inn dormitory and dining hall, the director's residence, the Monroe Gymnasium, and six master's cottages. The tree-lined streets of the campus were designed by Frederick Law Olmsted and converged at the steps of Memorial Hall. The school carried a prestigious reputation for a number of years. Its students included the likes of R. J. Reynolds, Jr. (son of R. J. Reynolds), as well as children of the Mellon and Carnegie families.

The school property and buildings were designated a National Historic District in 1984. The Tome School for Boys possesses significance in national architectural, educational, and military history covering the period 1900 to 1974. The school is significant in national educational history for its association with James Cameron Mackenzie, the planner of both the Tome School and the Lawrenceville School in New Jersey. The Lawrenceville School of 1882, upon which the Tome School plan was based, was the prototype of the non-sectarian college preparatory boarding school which proliferated in America during the late nineteenth and early twentieth centuries. Finally, the Tome School is significant in military history as the location of the Naval Academy Preparatory School (NAPS) from 1943 to 1974, excepting the years 1949 to 1951. The NAPS, the third oldest school in the U.S. Navy after the Naval Academy and the Naval War College, prepares enlisted candidates in the Navy and Marine Corps for admission to the Naval Academy. The NAPS was located in the Tome School buildings for a total of twenty-nine years covering a period of three major wars, during which the school played a continuing role in providing naval leadership for those conflicts.

After thriving for several decades, the Jacob Tome Institute fell into difficult financial straits during the Great Depression of the 1930s and closed in 1941. The following year, just after the United States entered World War II, President Franklin Delano Roosevelt approved the acquisition by condemnation of the property and land from seventy surrounding farms for use by the United States Navy as a training center. Meanwhile, the Tome School moved back to its original site on Main Street in Port Deposit. The institute's buildings were renovated for use by the Naval Academy Preparatory School to prepare future midshipmen for the U.S. Naval Academy further south at Annapolis, Maryland. USNTC Bainbridge was activated on October 1, 1942, and operated throughout World War II, the Korean War and Vietnam War, and the Cold War era. It closed as a military facility on March 31, 1976. During thirty-four years of operation, USNTC Bainbridge, (named for early-nineteenth century naval hero William Bainbridge) graduated over 500,000 recruits. Afterward, for over a decade,

the Susquehanna Job Corps Center occupied the campus until 1991. In 2000, the site was transferred to the State of Maryland, which subsequently turned it over to the Bainbridge Development Corporation. In 1971, the Tome School moved to a new, 100-acre campus in North East, Maryland. After many lives it seems the old Tome School buildings may have had their last run, sitting atop the cliffside and falling victim to vandalism, arson, and an impending end to this once beautiful campus.

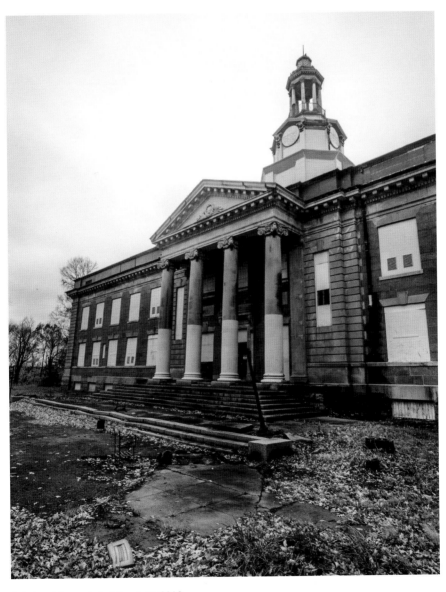

Exterior of the main building from 2010.

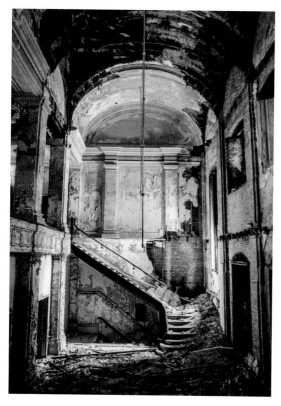

Main entrance staircase before fire.

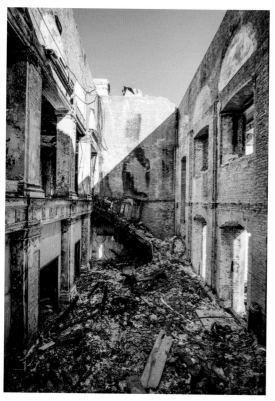

Main entrance staircase after fire.

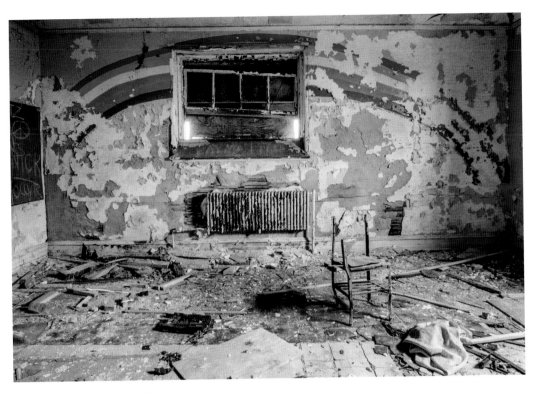

Rainbow room before fire.

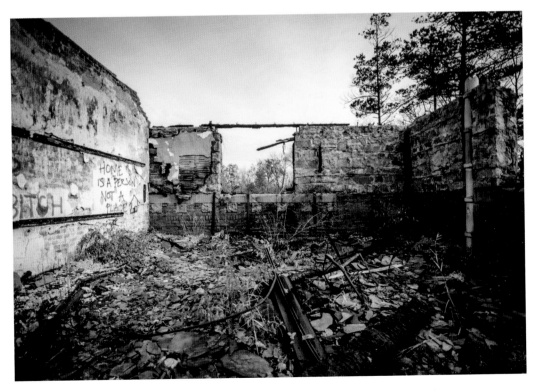

Rainbow room after fire.

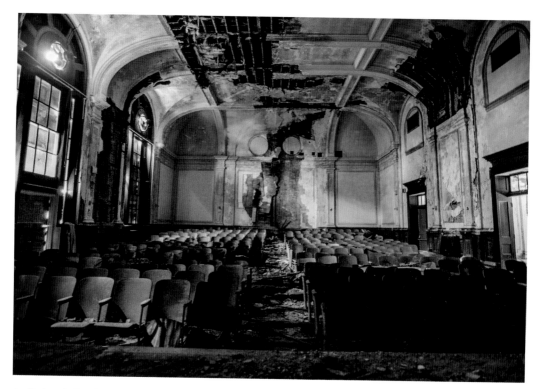

Auditorium before fire.

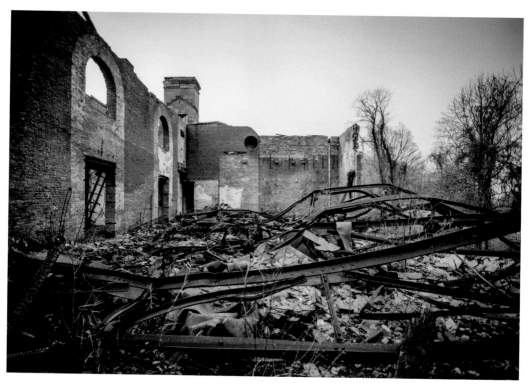

Auditorium after fire.

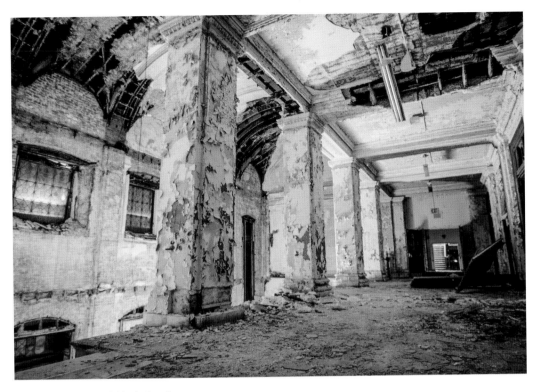

Second-floor lobby before fire.

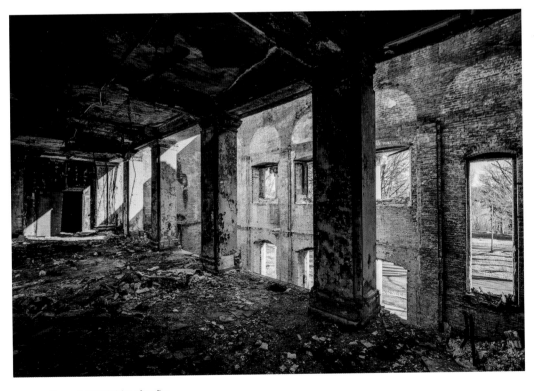

Second-floor lobby after fire.

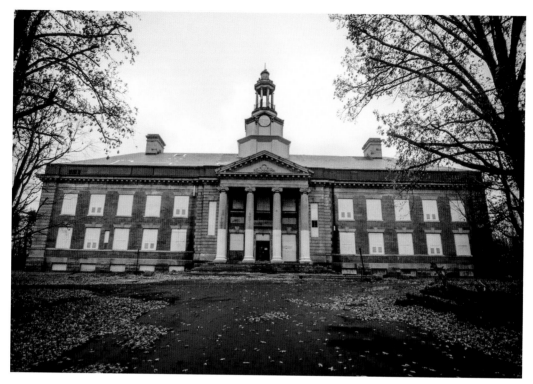

Exterior of the main building before fire.

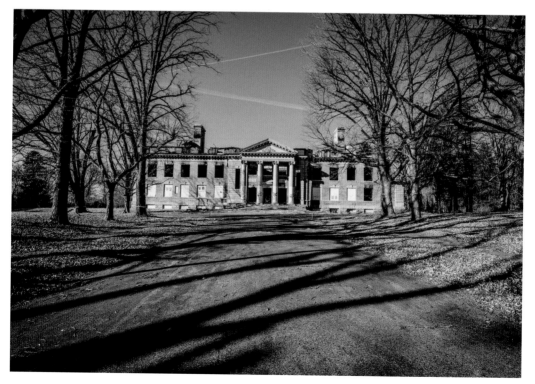

Exterior of the main building after fire.

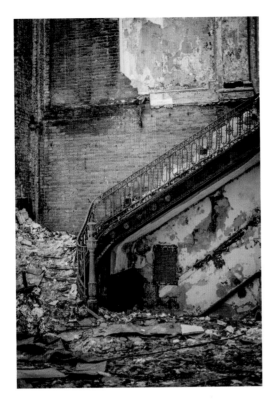

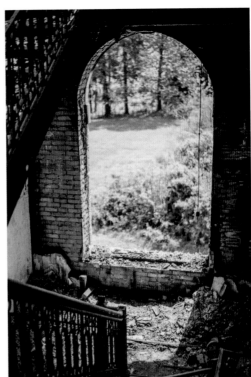

Above left: Burned handrail of the main staircase.

Above right: Grand window frame maintains structure even though all details have been burned away.

Right: Front-row seating.

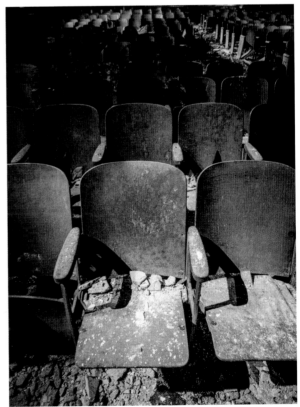

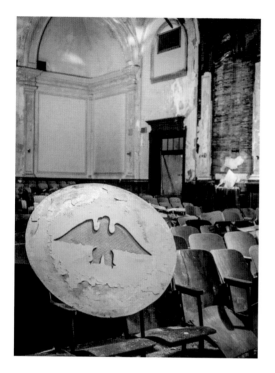

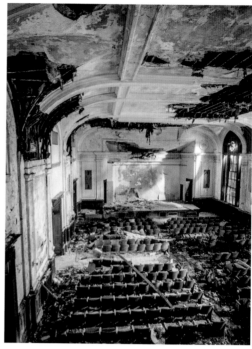

Above left: Fallen emblem resting on auditorium seats.

Above right: Auditorium seen from projector booth.

Left: Auditorium exit doors with seats in foreground.

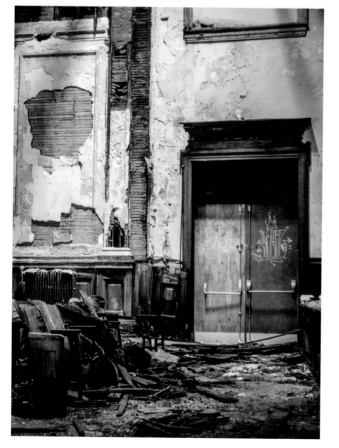

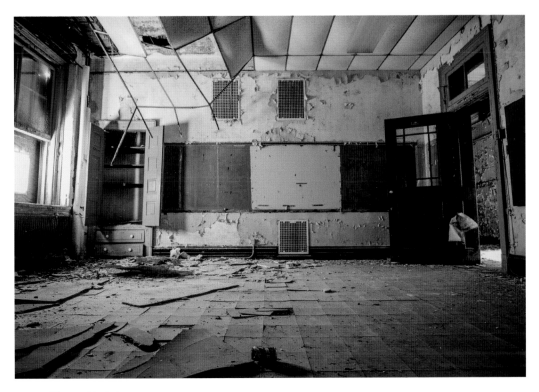

Blue and teal classroom.

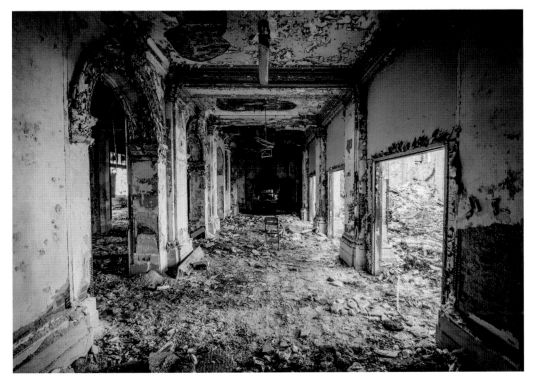

Main hallway beside cafe entrance.

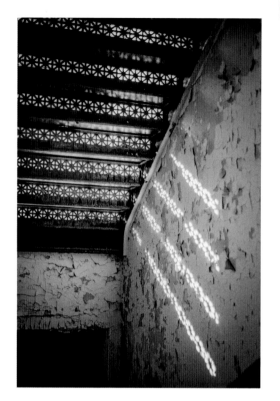

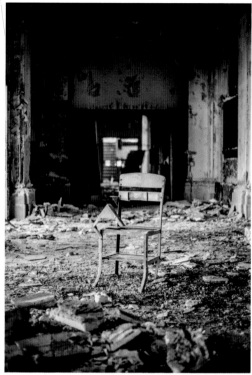

Light bleeds through decorative stair steps.

Classroom chair in main hallway.

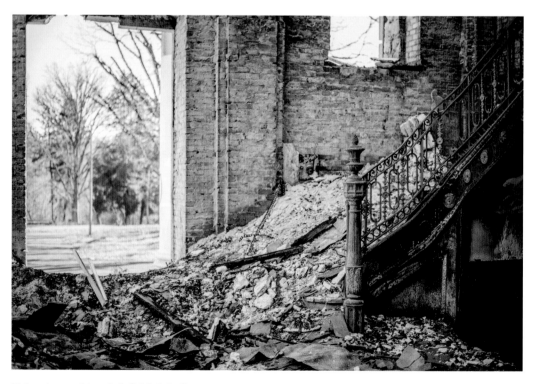

Main entrance stripped of all details by fire.

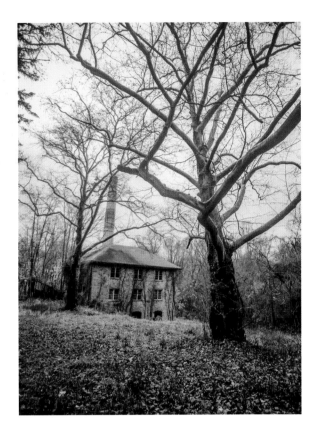

Right: Old pump house.

Below: Entrance and stairway of headmaster's residence.

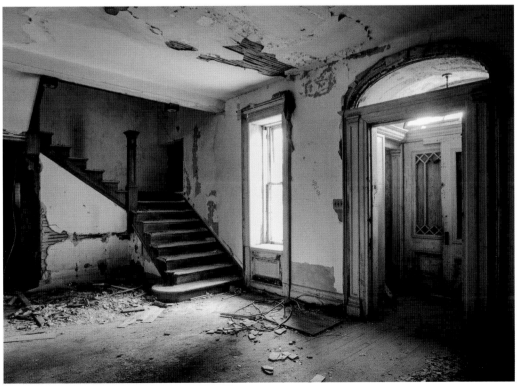

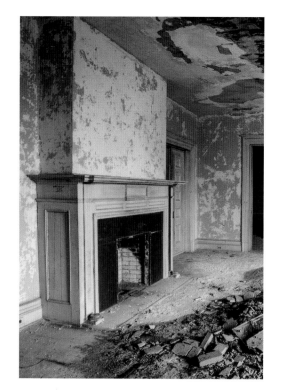

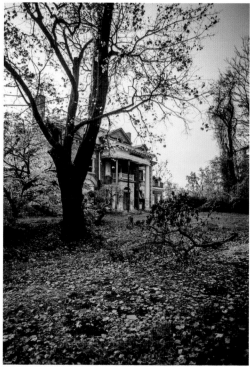

Fireplace inside the home.

Exterior of headmaster's residence.

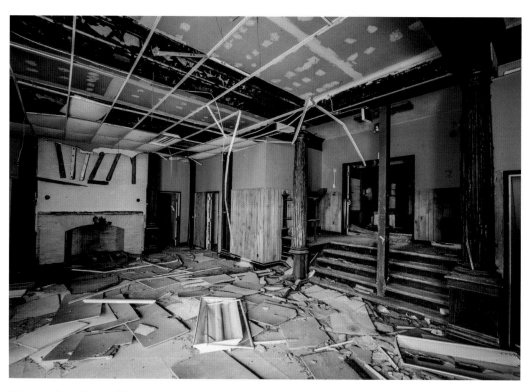

Entrance of dormitory building.

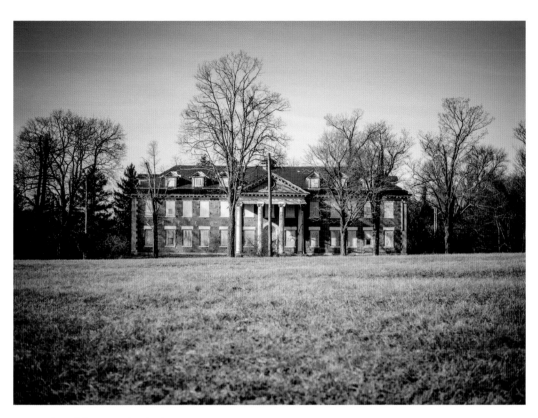

One of the many dormitories on campus.

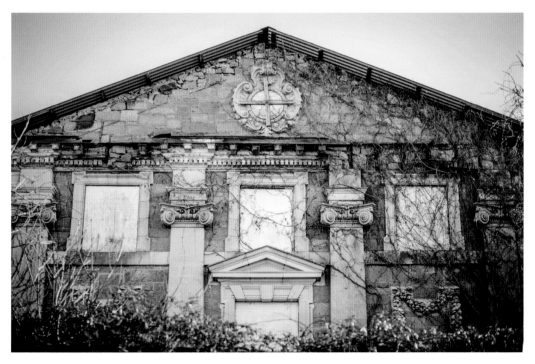

Detail of dormitory frieze.

2

BAINBRIDGE NAVAL TRAINING CENTER

T he remnants of the Bainbridge Naval Training Center are located on a 1,200-acre plot of land just off the Susquehanna River. This large area, before becoming a naval base, was home to a handful of short-lived townships. These towns, by the name of Heckarttown, Hawkinsville, and Gurleytown, did not last long; however, some of the old family farms remain in function, such as the Paradise Farm, owned by Oliver P. Hagerty, and the Heckart house from which the town was named, which served as a girl's school at one point in history. To the south of the property sat a black community known as Snow Hill before 1860, and atop the bluff overlooking the town sat the previously mentioned Jacob Tome School, the town's pride and joy.

In the earlier half of 1942 the town saw a dramatic change, as the U.S. Navy was to acquire the Tome School buildings as well as that 1,200-acre plot of land north of town. In a hasty fashion, the Navy sent a purchase request for the property to President Roosevelt, who served as the Under Secretary for the Navy, and had also done guest speeches at Tome School in the 1920s. Almost immediately the request was met, and the property quickly became U.S. naval property for training and recruitment. The federal government then went and sought out more land around the Tome School campus, which resulted in the abandoning of seventy or more family homes and farms. Lifelong residents of the area were moved from their homes in the efforts to train America to fight the World War. Unfortunately, the families were not offered much for their land, making it very difficult for them to rebuild what they had worked on for generations. The Tome School had been losing money since the Great Depression, however, and was eager to find a buyer who could support the prestigious school. The school campus then became home of the Naval Academy

Preparatory School, and the rest of the buildings served as a hospital, recreation facilities, warehouses, processing plants, and many other variations. During World War II, the men at Bainbridge trained on an eleven-week schedule.

After World War II, Bainbridge closed operation, but not for long as it reopened during the Korean War. During this time, the campus reached its largest capacity of 58,000 recruits. It repeated the same action, closing after the Korean War, and reopening for Vietnam. Unfortunately for the base, so many structures were built only as temporary in 1942 and were showing serious states of disrepair. It is said that there were numerous mothball and renovation efforts attempting to keep the facility operational, but they were all done with such haste that the buildings eventually could not stand the test of time. Bainbridge announced in 1973 that it would be closed by 1975; however, it managed to run until March of 1976. After a final closing ceremony, the gates were locked.

The federally run Job Corps Program then moved in, creating what was known as camps Susquehanna and Chesapeake to train under-educated and delinquent youth vocational skills, obtain a GED, and get into the workforce. This unfortunately proved deadly for what was left of Bainbridge. The property saw large amounts of fights and riots from the Job Corps students, and the buildings suffered from vandalism, neglect, and constant arson. After Job Corps left the property, it was shuttered for good, outside of cleanup efforts in hopes to sell the property. Throughout the next course of time, the town committees looked to redevelop the property, with suggestions of mixed-use development or a model city with massive employment centers. These plans hinged on the notion that the property became a development concern for the State of Maryland.

Just after a massive cleanup effort ran by the Port Deposit Heritage Corporation, known as Tome School Clean-Up Volunteers, with assistance from the Navy Seabees, things started to happen. Through this course of action, the Bainbridge Development Corporation was founded, and oversaw the future of redeveloping the old naval base. On February 14 of 2000, representatives from the federal, state, and local government, along with the U.S. Navy, heritage organizations and the Bainbridge veterans, held a ceremony at the main gates. Now the redevelopment of the property was under the eyes of many. A slew of rumors about the development of the old property circulated—a federal prison, NASCAR track, maybe even a Disney amusement park. The property remains vacant, and in shambles, as an unfortunate reminder that nothing has been done to this day. To think that in 1942 they were able to level 1,200 acres of land, construct 506 buildings with a railroad system, movie theaters, sidewalk, a hospital complex, and essentially an entire town. Yet now, in the face of the modern day, they can't get a single shovel head in the ground.

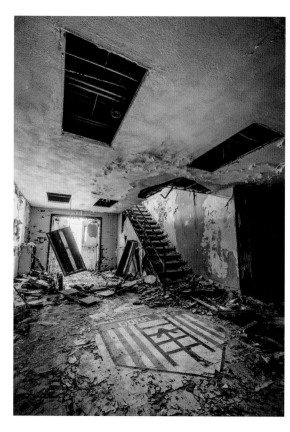

Left: Main entrance to the soldier's dormitory seal in the foreground.

Below: Recreation room now full of cabinets.

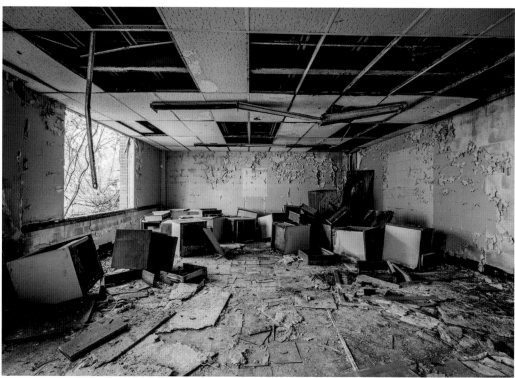

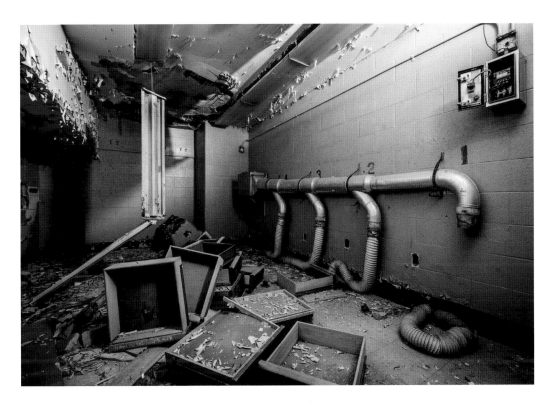

Above: Leftover parts of the second-floor laundry room.

Right: Caged room beside stairway entrance.

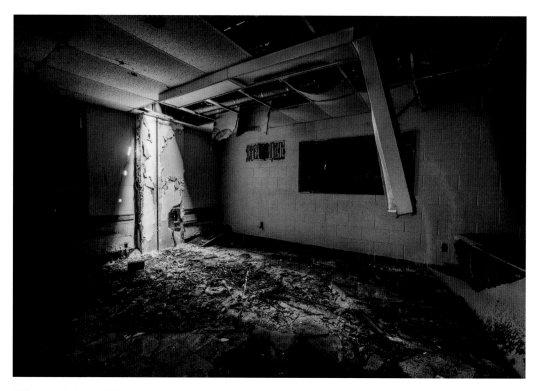

Light pours in from a hole in the room.

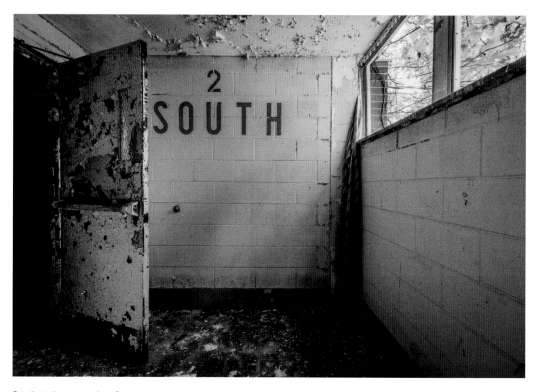

South stairway number 2.

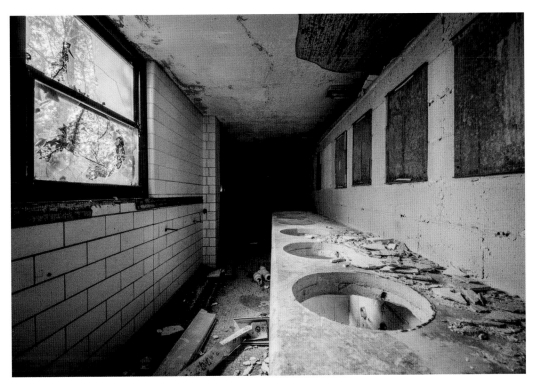

Long row of sinks in the washroom.

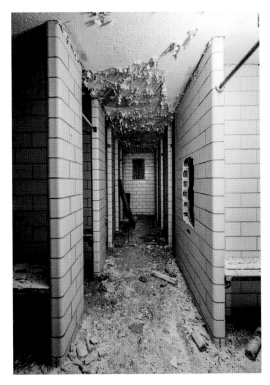

Rows of shower stalls.

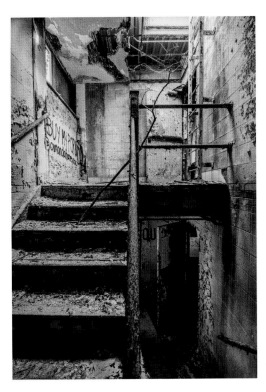

A decaying stairway displays many colors.

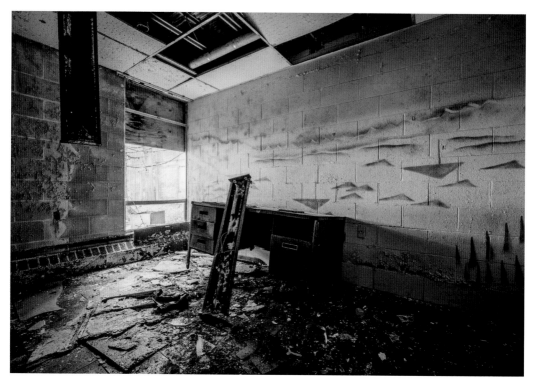

Office with sailboat art on the wall.

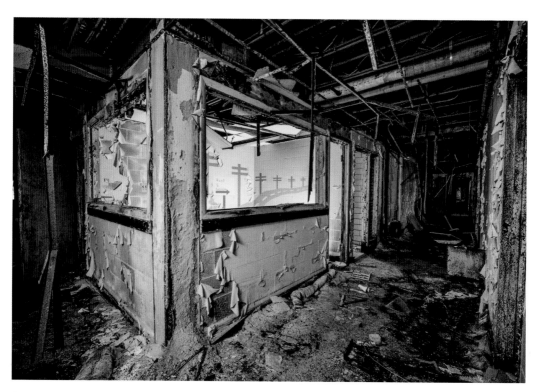

Corner station in hallway.

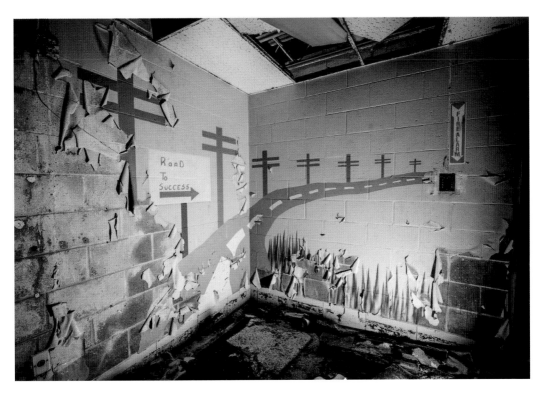

Art inside the hallway corner station.

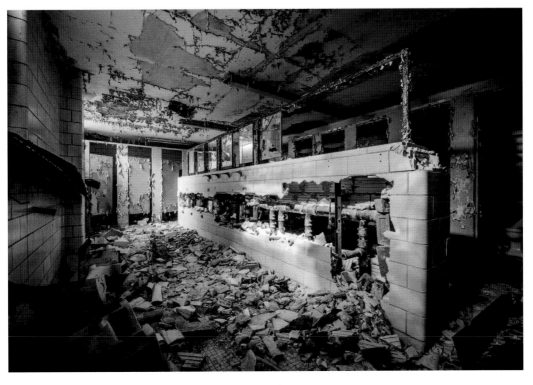

Bathroom sinks smashed from vandalism and scrapping.

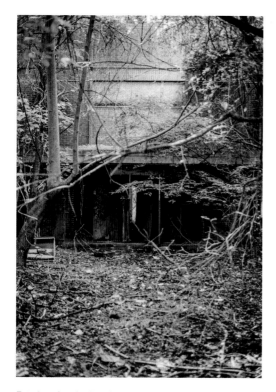

Exterior of main dormitory.

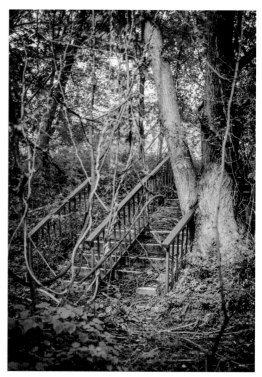

Exterior staircase taken over by nature.

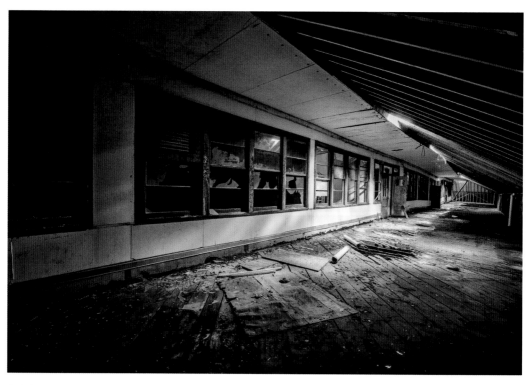

Attic in workshop building.

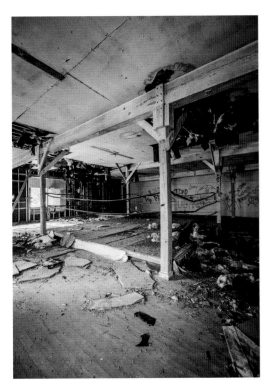

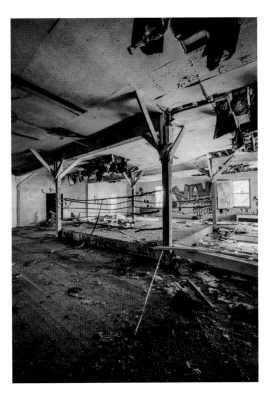

Boxing ring found on the second floor far corner of the workshop building.

Reverse angle shows a boxing ring was used by local kids as a wrestling ring for their wrestling league, "WLW."

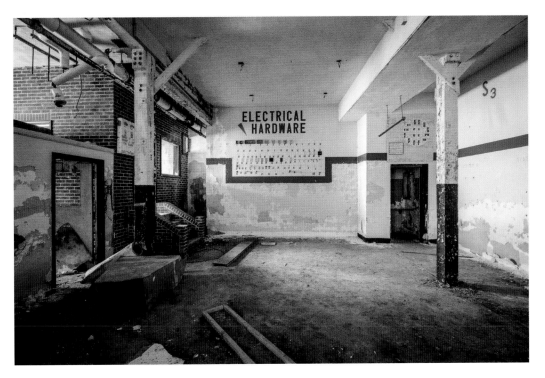

Electrical training room inside workshop.

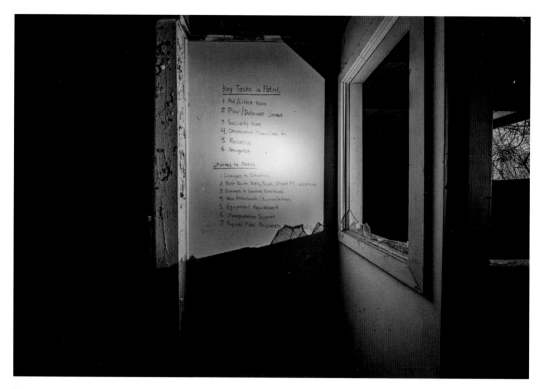

Tasks of patrol written on the wall inside a workshop.

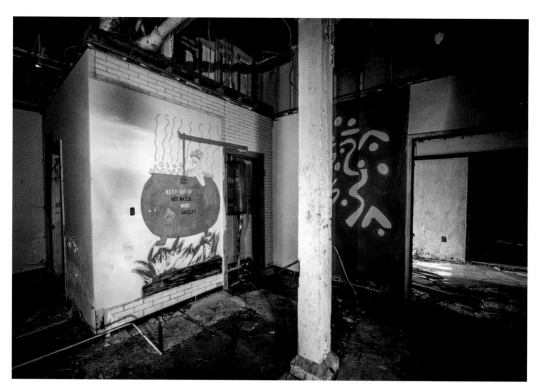

Wall art found inside a workshop.

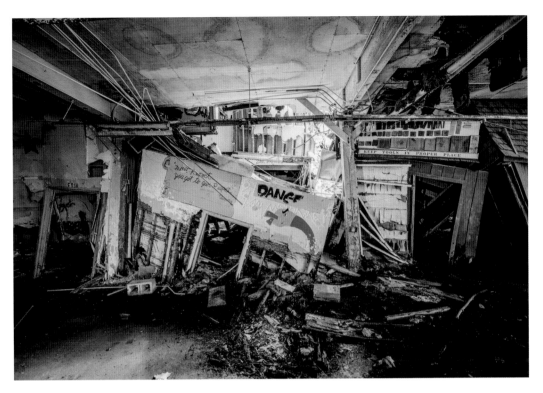

Collapse inside the workshop classroom.

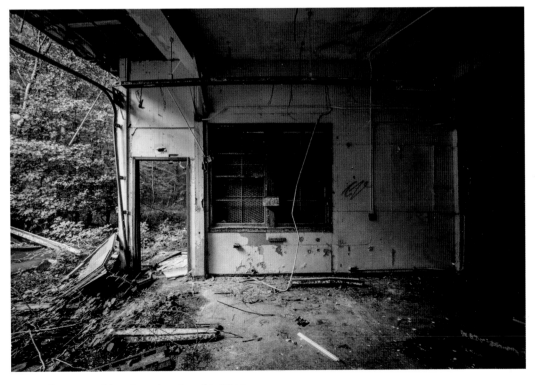

Doorway next to collapsed portion of building.

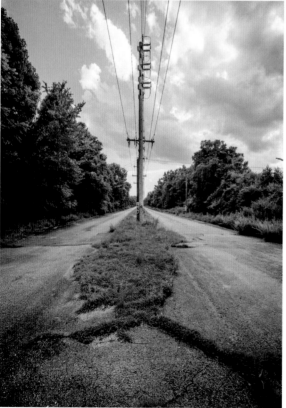

Above: Exterior displaying building number 103.

Left: One of the main roads through the campus, vacant, and stretching for over a mile.

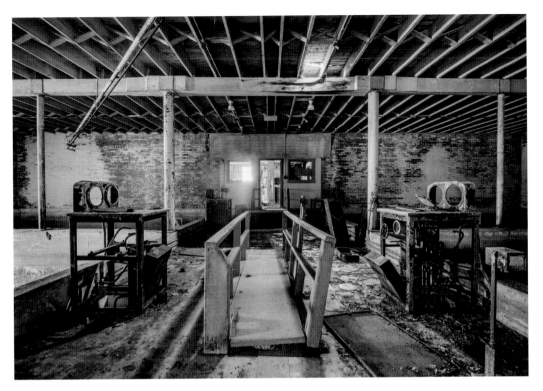

Interior of water treatment building.

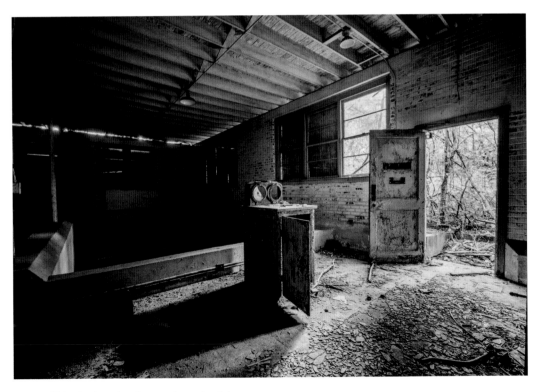

Water treatment system reader and exit door.

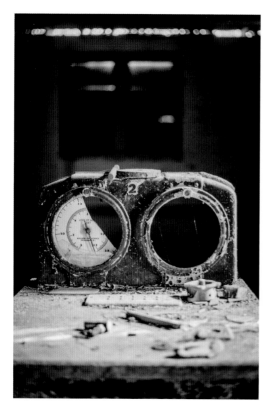

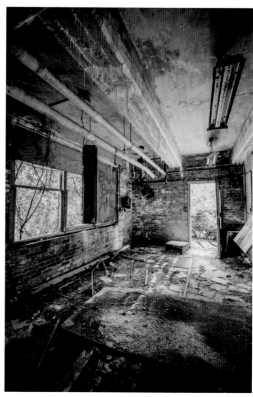

Above left: Detail of reader.

Above right: Backroom of plant shows years of wear.

Left: Old typewriter slowly decays away in old office.

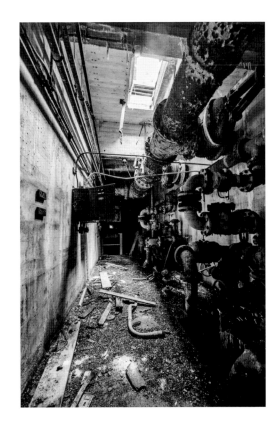

Right: Tunnel to underbelly of the plant.

Below left: Piping beneath the water treatment plant.

Below right: Water from the old fort reservoir floods into the basement of the old plant.

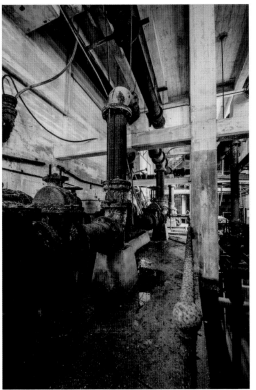

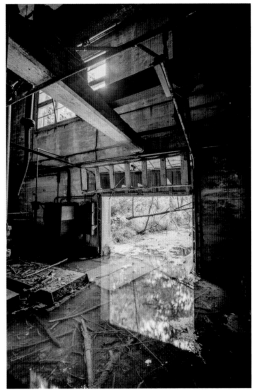

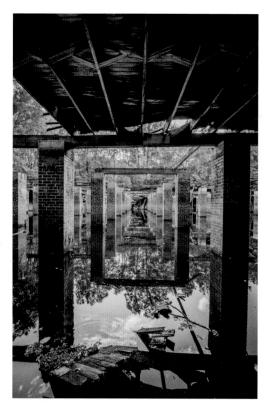

The plant's covered reservoir has collapsed over the years of neglect.

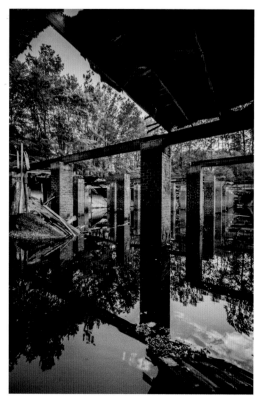

Another angle of the unique covered reservoir.

3

BRANDYWINE SANATORIUM/ EMILY P. BISSELL HOSPITAL

O riginally located in the Timiken Woods on a plot of land along the Brandywine creek, the Brandywine Sanatorium served as a tuberculosis hospital. But in 1907, it nearly failed in the need of some funding, 300 U.S. dollars that is. It may sound like nothing now, but back then this was no simple task. A doctor by the name of Joseph Wales who worked at the sanatorium soon after reached out to his cousin, Emily P. Bissell. Emily was known for her work in fundraising, and thus Doctor Joseph wrote a letter to his cousin, pleading for her help.

Emily P. Bissell was born in Wilmington, on May 31, 1861, to a prominent family. She developed a humanitarian outlook at an early age, and in her twenties began fundraising money to provide social services to immigrants, and for the city's first kindergarten. Upon receiving the letter, Emily was moved emotionally and began thinking of ways to come up with the needed funds. She was inspired by a Denmark man named Jacob Riis, who had started the sale of Christmas Seals, a special postage stamp sold around the holidays, to raise money for his charities. Emily went forward with a similar approach, creating a Christmas Seal of her own to hopefully save her cousin's sanatorium. With approval from the Red Cross, she used their logo, and sketched a design combining the Red Cross logo and a holly wreath. She then began her one-woman campaign to fundraise through these seals.

Emily's first seal sold in a Wilmington post office for only one cent each. Emily increased sales by getting the press involved, each day the newspaper published articles under the heading of "Stamp Out Tuberculosis." Even President Theodore Roosevelt gave his full endorsement to the campaign after hearing of Emily's efforts.

At the end of the 1907 Christmas season, Emily's campaign had raised 3,000 dollars—well above the needed 300 to save the sanatorium. In 1908, the campaign

had grown so much that it became a national program administered by the National Association for the Study and Prevention of Tuberculosis (NASPT). Emily led her campaign as an active promoter and continued to devote her life to fighting tuberculosis until her death in 1948. Brandywine Sanatorium was renamed the Emily P. Bissell Hospital in 1957 in honor of the kind and strong woman who once saved the sanatorium, and therefore anyone administered to it.

The buildings that still stand to this day began construction in 1910, and by 1919, it was an eighty-person capacity facility, growing ten times the original capacity of eight beds before 1910. Eventually, the facility changed to become a state-run long-term care facility, as it remained until its closure. Over the years the facility wasn't holding up to a modern standard of taking care of the elderly, and ultimately the city decided to have it closed in the best interest of making sure patients can age comfortably at smaller facilities, or with in-home care. Emily P. Bissell Hospital closed in the latter half of 2015.

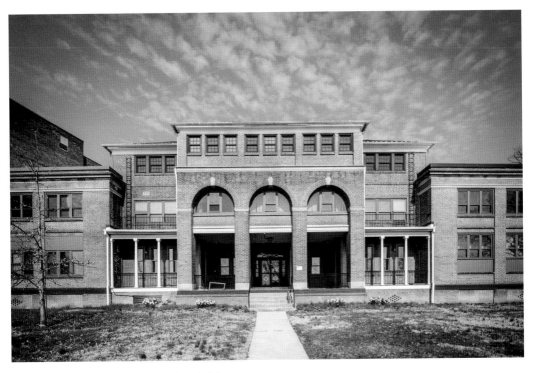

Exterior of the original sanatorium building.

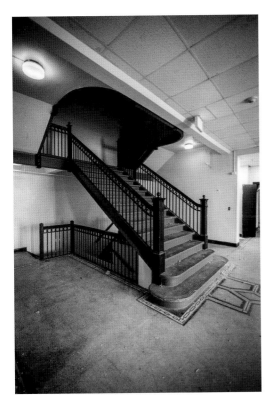

Main staircase inside the original building.

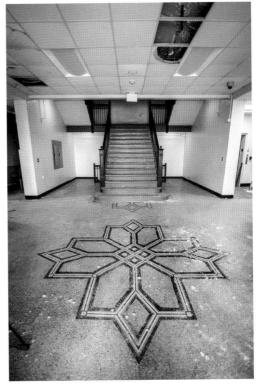

Decorative seal and staircase of the main entrance.

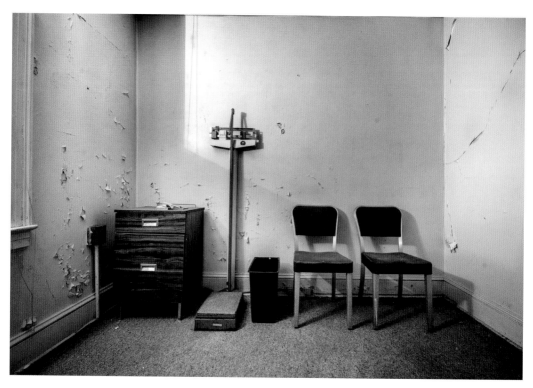

Check-in room beside an exam office.

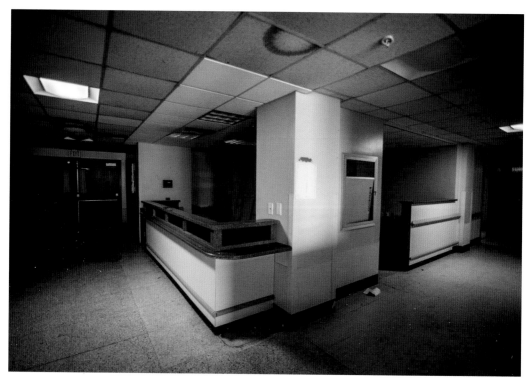

Corner nurse's station along a main hallway.

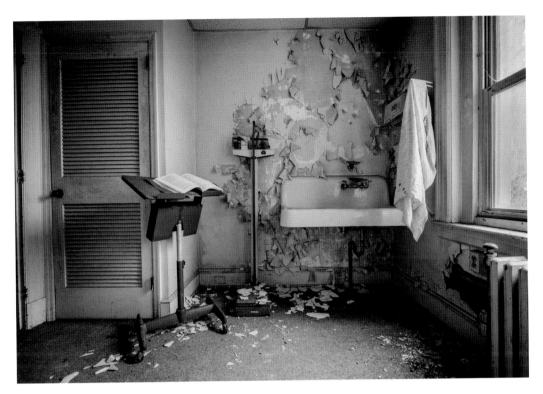

Wash area near patient rooms.

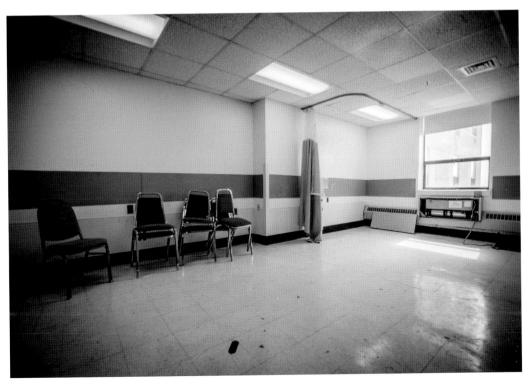

Chairs stacked inside the outpatient area.

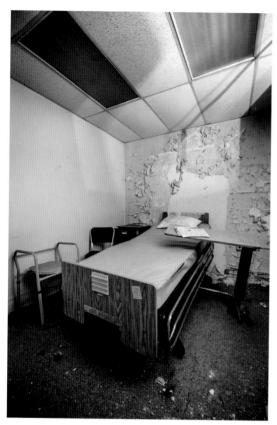

Left: A hospital bed in a small inpatient care room.

Below: Staircase and wheelchair inside an original sanitarium building.

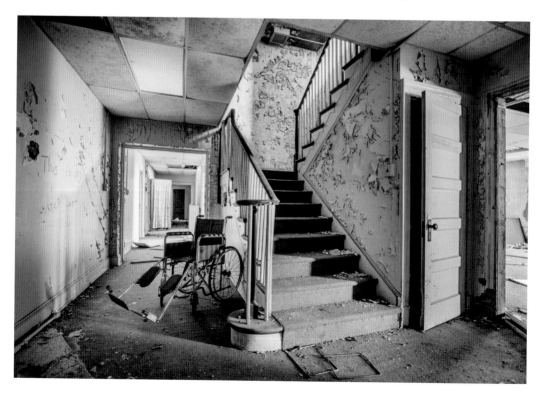

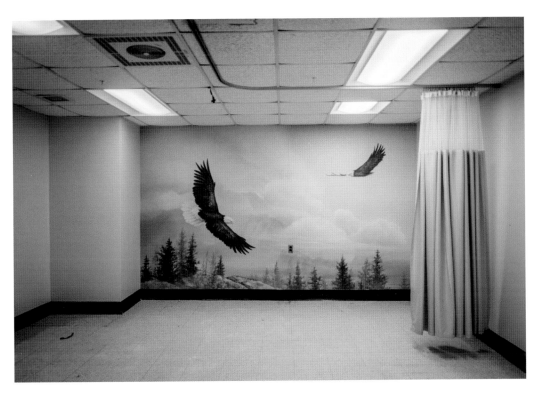

Wall art behind separation curtain.

Vacant room inside the newest portion of the hospital.

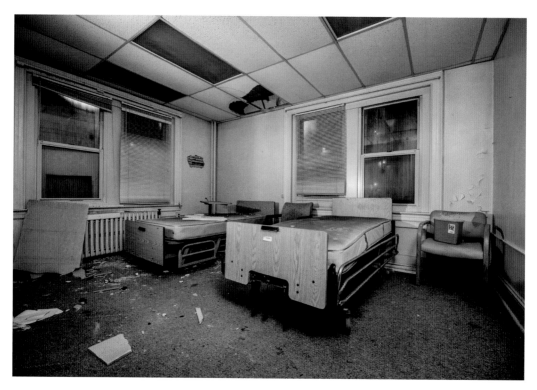

Another inpatient room set for visitors.

Needles spill out of a biohazard container.

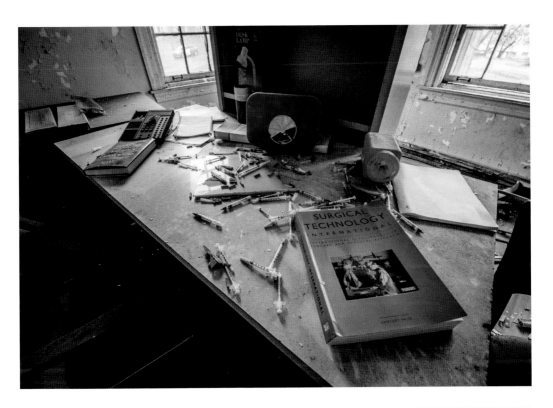

Above: More needles spilled across an office desk.

Right: Body freezer in the basement of the old sanitarium building.

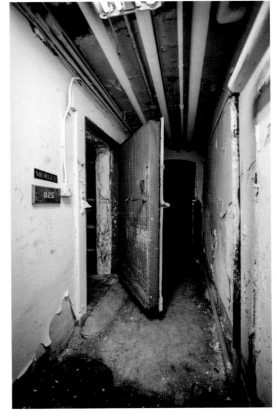

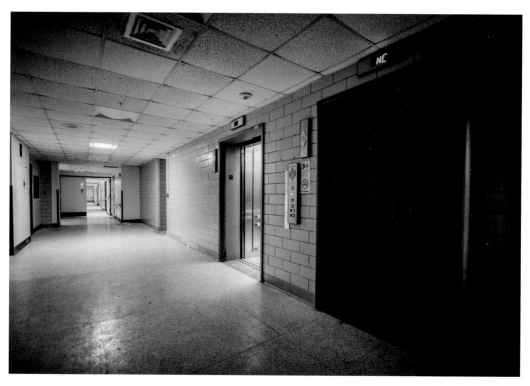

Hallway inside the newer portion of the hospital.

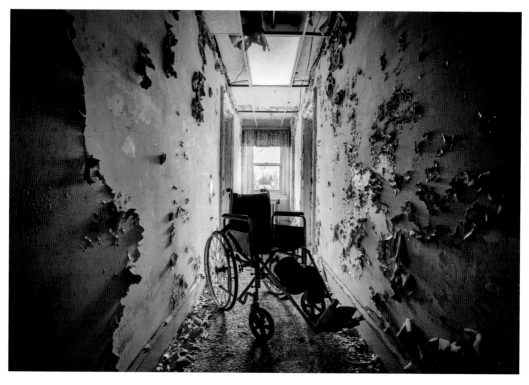

A wheelchair sits in a decaying hallway.

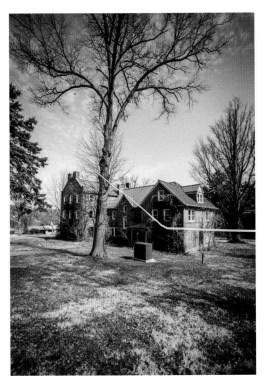

Exterior of the nurses' residence building.

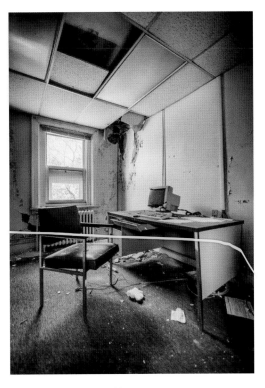

Office inside nurses' residence.

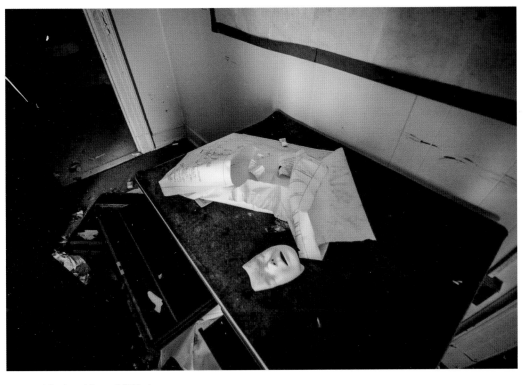

Misplaced face of CPR dummy.

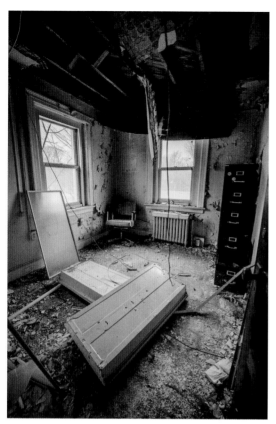

Left: Decaying room inside nurses' residence.

Below: Office in shambles inside repurposed resident's home.

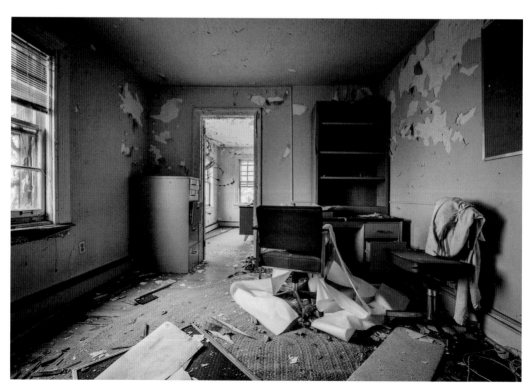

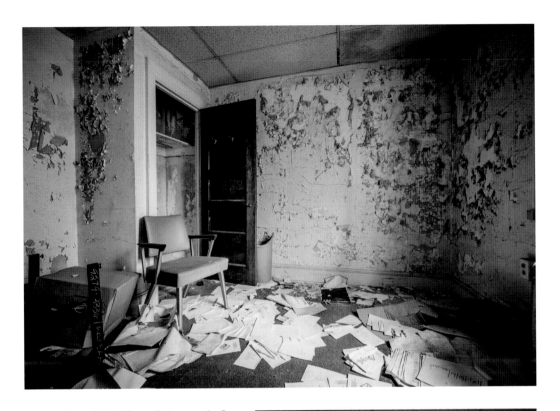

Above: Patient files spilled across the floor.

Righ: Food safety pins scattered across a room of storage.

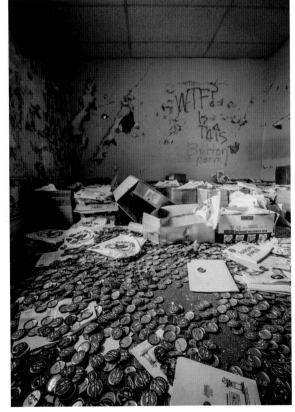

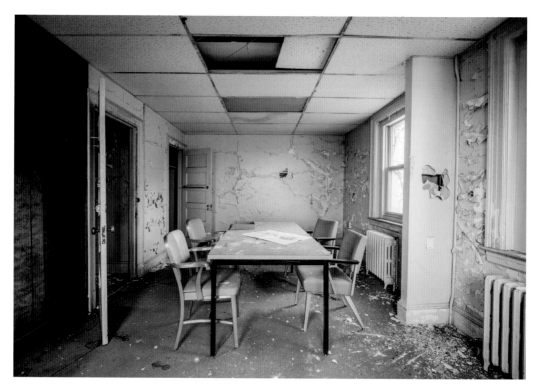

Meeting room.

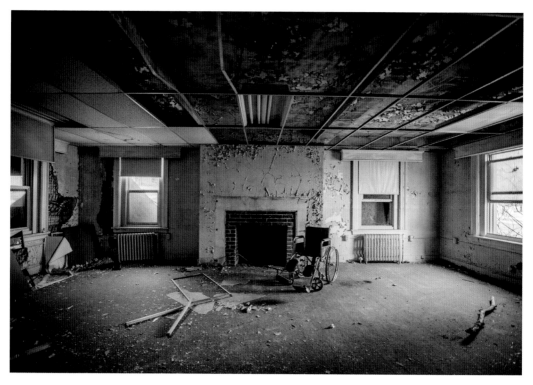

The recreation hall of nurses' cottage.

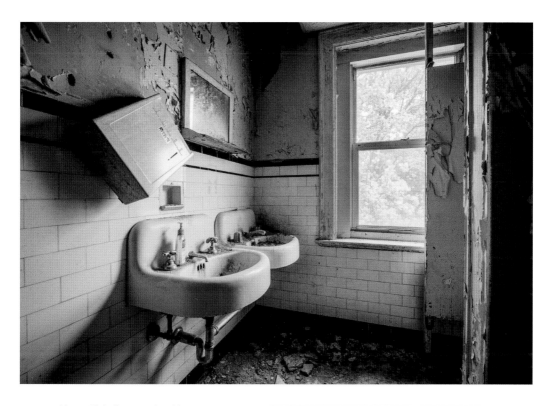

Above: Sinks in nurses' residence.

Right: Card organizers store in the basement of an office building.

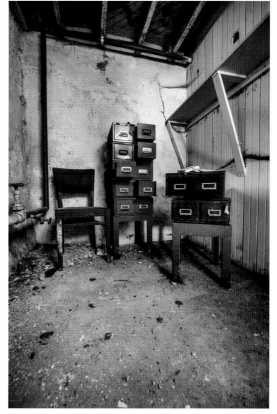

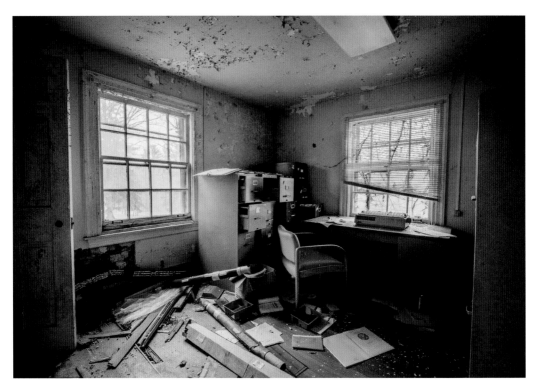

An office in shambles.

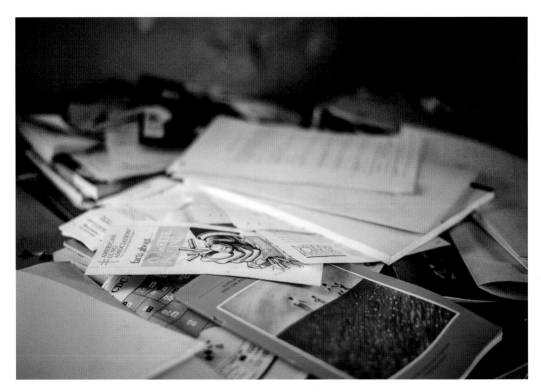

Pamphlets rested on file cabinets.

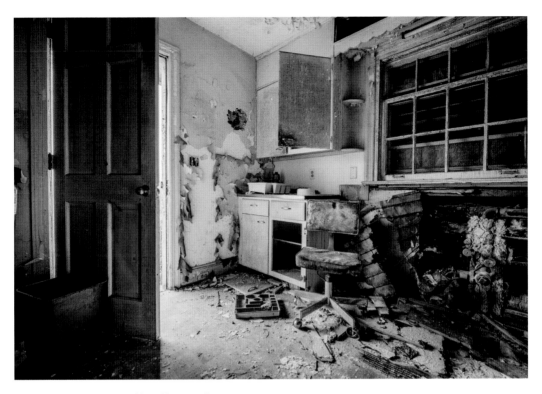

Backdoor to old residents' home swings open.

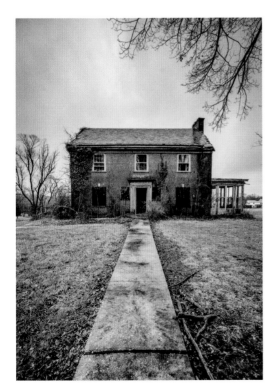

Exterior of old residents' home.

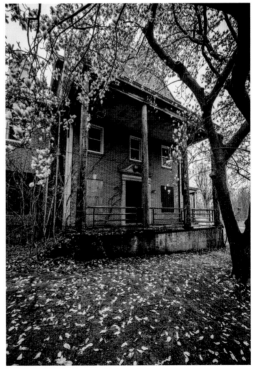

Front of the old nurses' residence.

4

BLOXOM ELEMENTARY SCHOOL

In the year of 1884, when the railroad was brought to the Eastern Shore, one of the many stations was in Bloxom, VA. Bloxom started to grow—as small towns did around the railroad—into a nice community. A post office was built, and the railroad authorities named the town after its first postmaster, William E. Bloxom. Entering the twentieth century Bloxom had become a full-fledged town and stop along the rails, complete with a restaurant, general store, hotel, multiple bars, and an undertaker. The town exported produce and barrels, and during the holidays would even make holly wreaths and ship them up to New York and Philadelphia. In 1931, the town opened its house of education, a large two-story brick structure which stands to this day. Bloxom's claimed "heyday" was in the late 1930s and throughout the 40s when they were able to offer the amenities of a doctor, barber, feed store, banks, and a grocery store. In 1952, it finally housed its own Volunteer Fire Department. After World War II, as the automobile took business from the railroad over time, towns like Bloxom suffered. As highways were built, the railroad receded, and Bloxom began to fade out of prominence. By the 1980s, most of Bloxom had either been dismantled and moved down to Cape Charles or burned like the old freight station that once brought the town life. Bloxom School was able to remain operating until 1998 when it shut its doors for good. The years have not been kind to the old school building, and despite an individual from Delaware purchasing the property to renovate it into a showcase home some years ago the building remains vacant. Placed in front of the old Bloxom Elementary sign was a sign that read "Bloxom School Restoration Project." However, that sign has been missing for some time now, and the old school sign smashed to pieces. The roof of the structure in many parts has collapsed, allowing the elements into the structure and bringing down sections of flooring with it. Sadly, the fate of the school appears to be that of letting Mother Nature claim what was once hers.

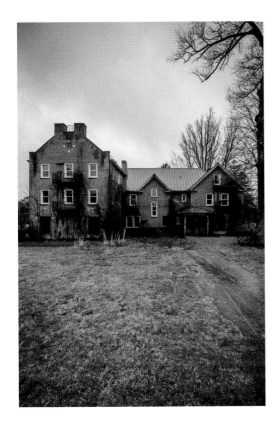

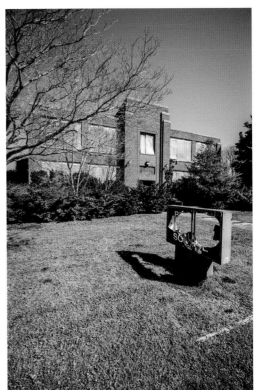

Above left: Rear of the old nurses' residence.

Above right: Exterior of school with broken sign in foreground.

Right: Retrofitted glass door inside the old school.

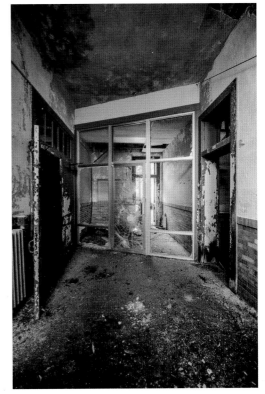

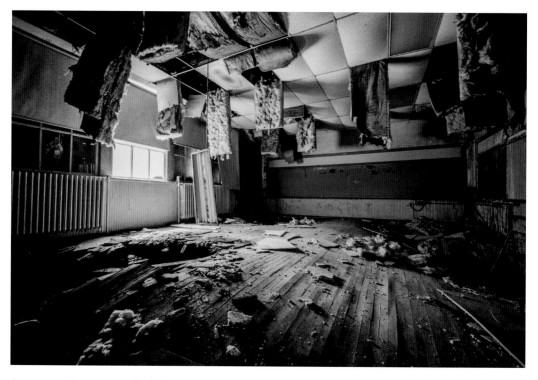

A classroom drop ceiling begins to fall.

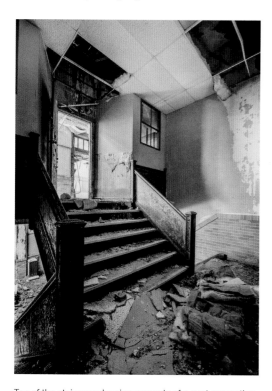

Top of the staircase showing example of a past renovation.

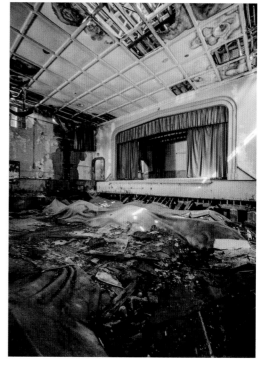

The theater where the stage appears to float as the floor beneath it has collapsed.

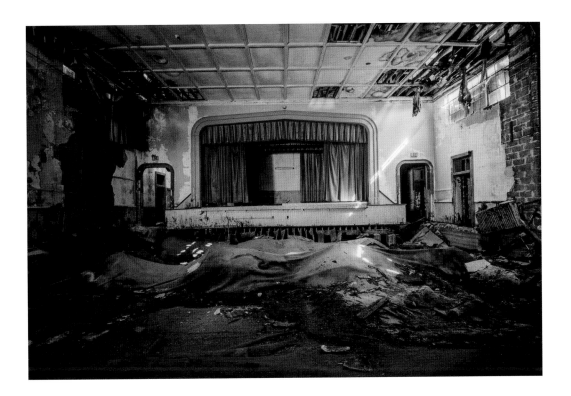

Above: Another angle shows the years of decay.

Right: Collapse on the backside of the stage.

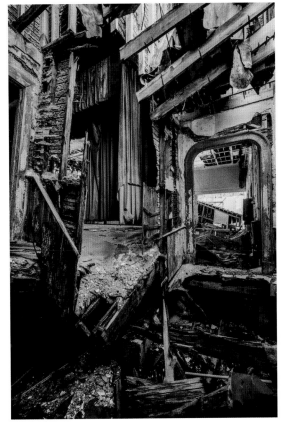

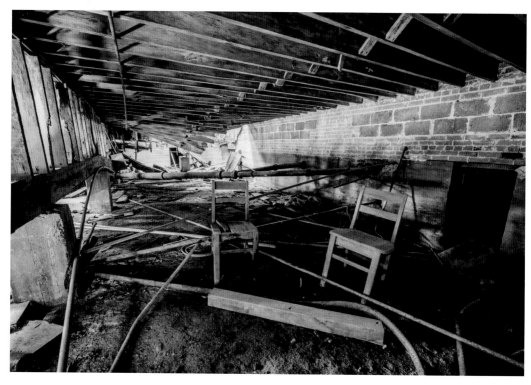

Chairs hidden under the stage. Can't help but imagine students hanging out down there.

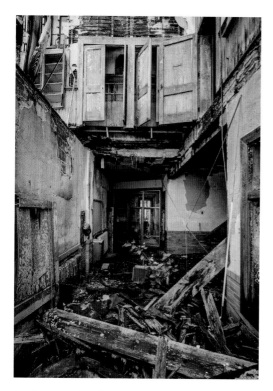

A collage reveals a diagram-like view of the structure.

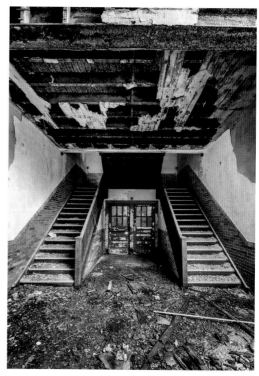

The main school staircase.

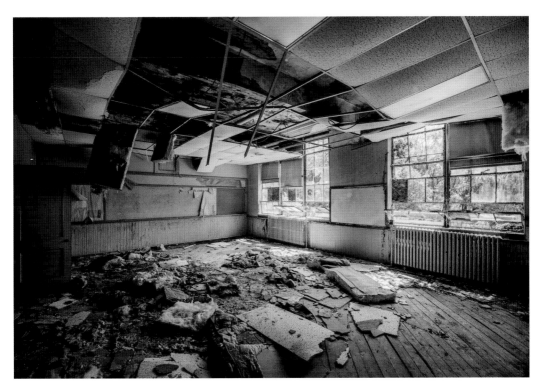

Classroom rots away.

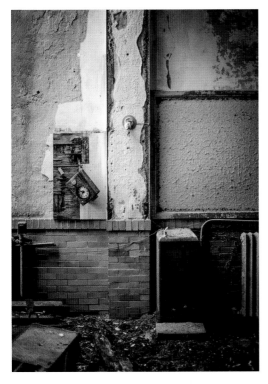

Old punch clock and water fountain rot side by side.

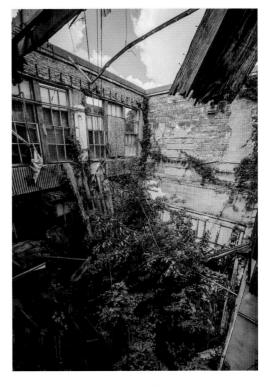

A collapse seen from the second-floor hallway.

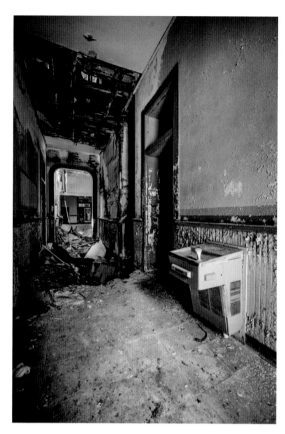

Left: A water fountain in a back hallway remains in fair condition.

Below: Very small cafeteria shared function as a classroom.

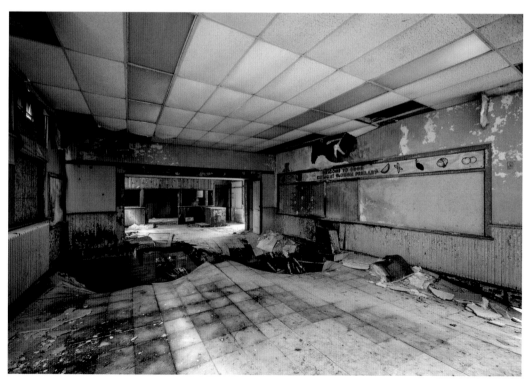

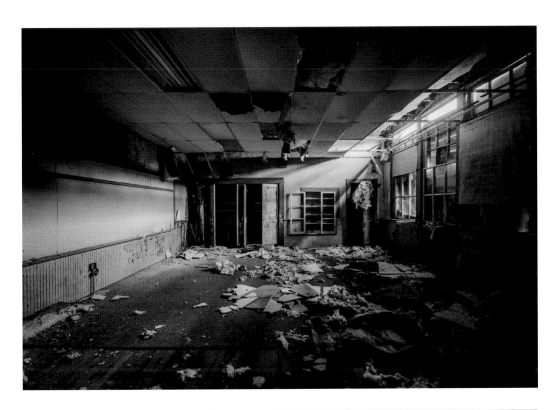

Above: A sliver of light cuts into a classroom.

Right: Collapsed principals' office.

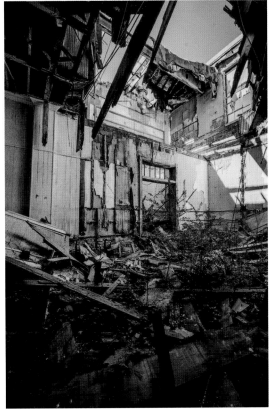

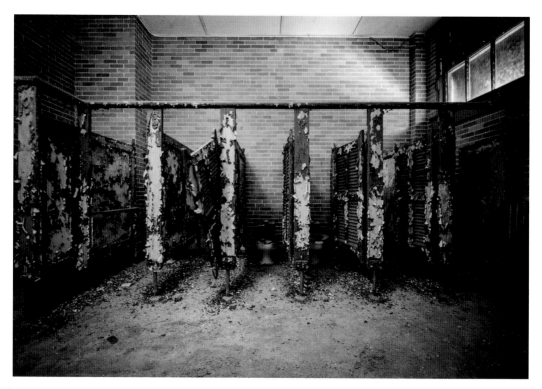

Yellow bathroom stalls.

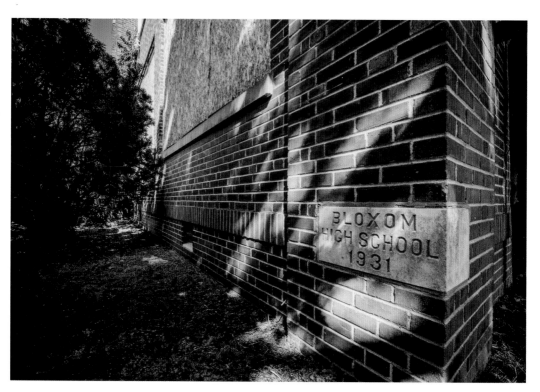

Exterior cornerstone.

5

BANCROFT MILLS, WILMINGTON

On March 25, 1831, Joseph Bancroft, a gentleman trained in textile weaving in Lancashire, began running a cotton mill located along the Brandywine River in Wilmington, DE. It was originally called Joseph Bancroft & Sons Cotton Mill, sometimes known as Rockford Cotton Mills, Brandywine Cotton Mills, or James Riddle & Sons Mills. It was constructed along the Brandywine River to take advantage of the river's powerful waters to run the hydro plant that powered the mill. Bancroft adopted the traditions of British spinning and weaving technologies for his own operations at the mill.

The company expanded significantly in the 1830s and 1840s as it began to produce and distribute cotton for Philadelphia and New York markets. Joseph Bancroft brought his two sons on board the company in the late 1840s, assuring the company's future to remain in the family. During the Civil War the Bancroft Cotton mills prospered. As American markets were largely closed to English imports, other American textile enterprises also benefited from the situation. Once the Civil War was over, the Bancroft company spent time researching and developing a new bleaching process and began focusing on finishing cotton cloth. At this time, the mills became known as the Joseph & Sons Company and were incorporated on October 1, 1889. The Bancroft Mills were referred to as the largest textile finishing operation in the United States then, and had the longest history of textile milling in the Brandywine Valley.

In the mid-1930s, Bancroft started production in rayon goods, and a cotton finishing process that was marketed under the trade names of "Ban-Lon" and "Everglaze." Both processes were widely licensed in Europe and America and in the early 1950s, seventy percent of the company's total profit was accounted for

by foreign royalties. The Bancroft Company became a division of Indian Head Mills Incorporated, a New York City based company, in 1961. The Joseph Bancroft & Sons Company sponsored the Miss America Pageant and promoted their fabrics though the pageant from 1953 to 1967. Miss America modeled her official Everglaze and Ban-Lon wardrobe along with other models, including those for men's and children's clothing. There were fashion shows featuring Miss America's Everglaze wardrobe and clothing created using McCall's patterns in fabrics by Everfast; displays of fashions and fabrics in department stores; and the use of Everglaze and Ban-Lon fabrics for household furnishings such as draperies, upholstery, and bedding.

After 130 years of being a family owned and operated company, Bancroft Mills then became a wholly owned subsidiary of Indian Head Mills in September of 1961. The plant became increasingly unprofitable as the Northeastern textile industry eroded, and in 1966 Indian Head Mill Incorporated became a conglomerate called Indian Head, Inc., and the finishing plant was listed for sale in 1972. It was purchased by the Wilmington Finishing Company, composed mostly of Bancroft department heads, on June 4, 1973. Indian Head Inc. sold the Joseph Bancroft & Sons Company, which by now was reduced to the licensing operation, to Beaunit Corporation in February 1975. In 1981, the old Bancroft Mills building closed its doors, ceasing operations after their 150 years of operation. The mill complex is undergoing a continuing project to restore the old mill into condominiums, the completed portion of the mill saw the reuse of two of the nineteenth-century textile mill buildings. One of the buildings restored in the project was a three-story stone milling building that dated back to 1848. Bancroft Mills is architecturally significant, as well as historically significant to the textile industry, and for that has earned its place in history. In 1984, the Joseph Bancroft & Sons Mill was on the National Register of Historic places.

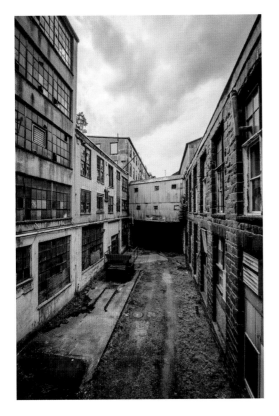

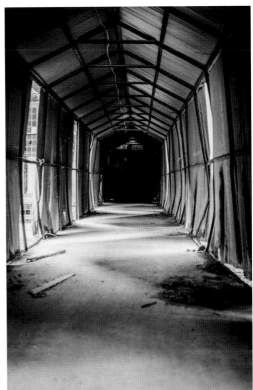

Above left: Exterior road cuts through the building complex.

Above right: One of the covered breezeways that travels from building to building.

Right: A chair cornered between two windows.

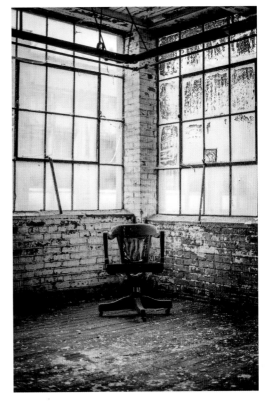

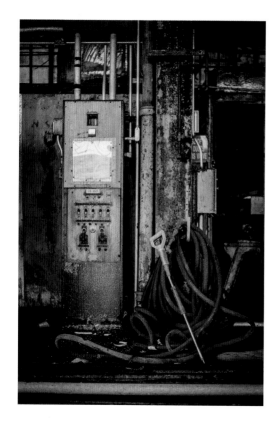

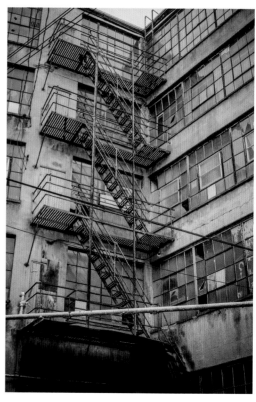

Above left: Hose and pressure washer still wrapped from its last use.

Above right: Fire escape lines the side of a building.

Left: Fabric still stuck in the machinery from the day they turned it off.

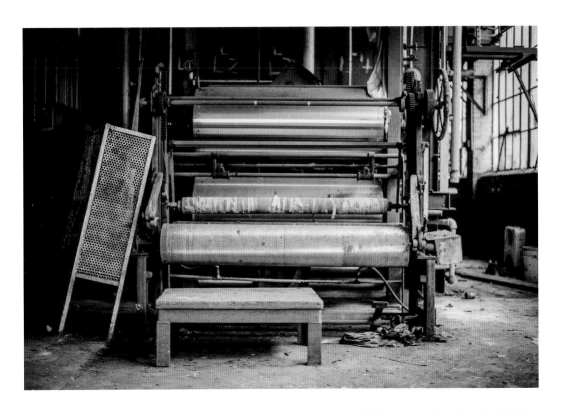

Above: Workstation with bench awaiting employees.

Right: More textile caught in machinery from the day of closure.

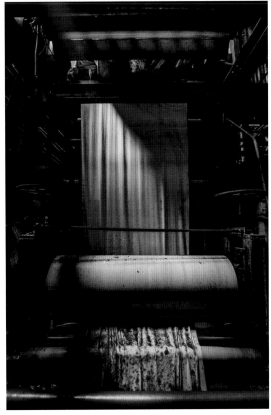

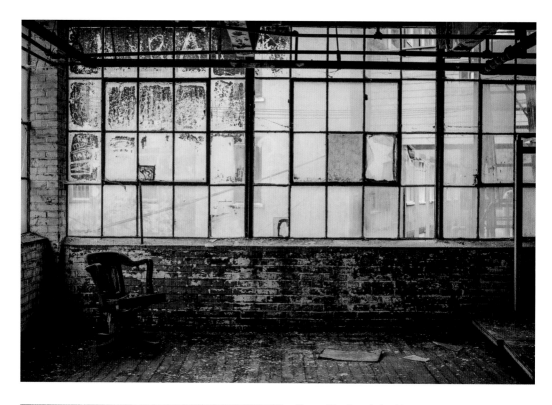

Above: Wooden chair with pane windows.

Left: Exterior courtyard.

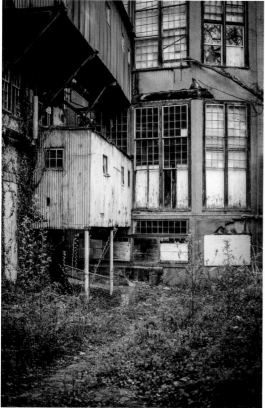

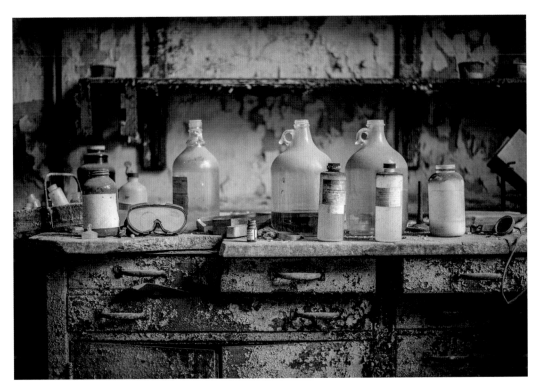

Chemical bottles inside an old lab.

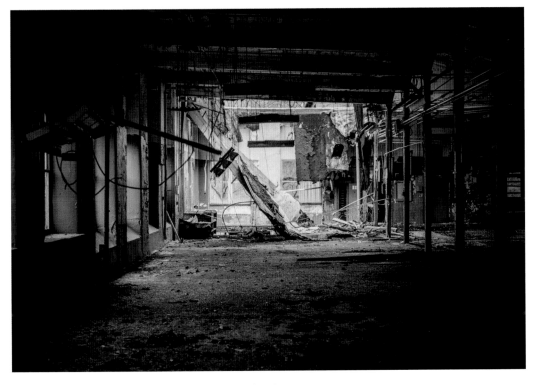

Collapse in production room shows the years of neglect.

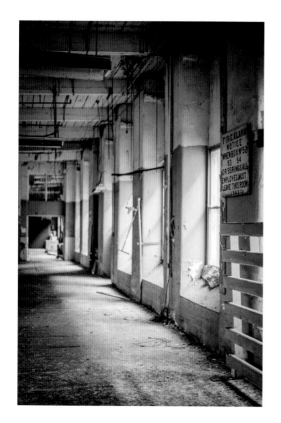

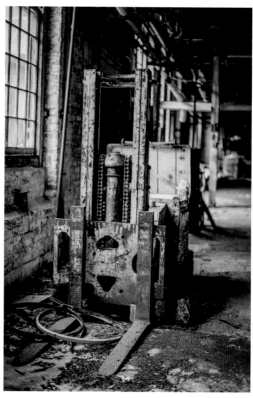

Above left: Long hall with signage.

Above right: Heavy machinery left behind.

Left: More heavy machinery.

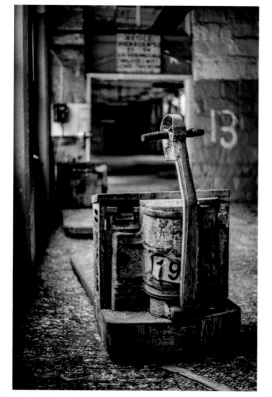

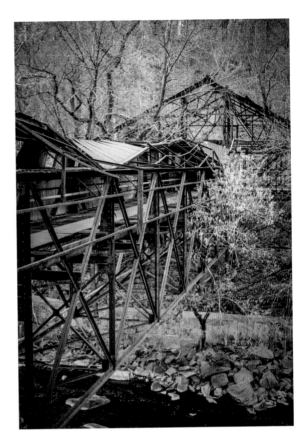

Right: Exterior walkway over the Brandywine River.

Below: A cart full of fabric rots away.

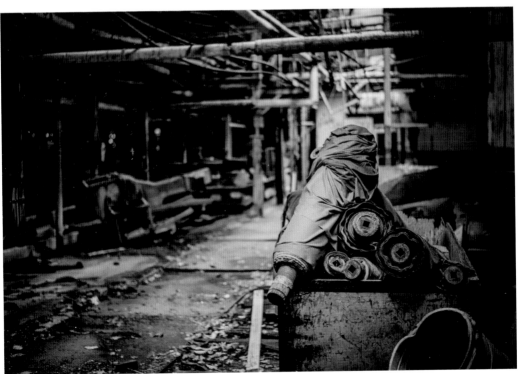

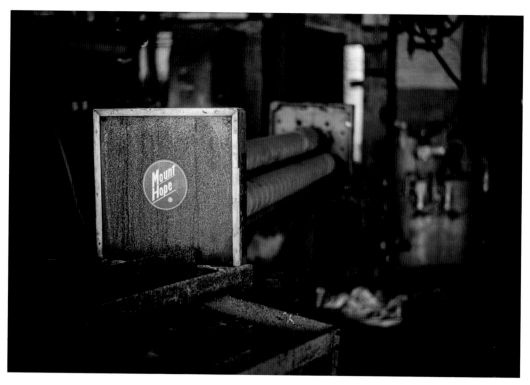

Logo on the side of machinery.

Storage shelves in the maintenance area.

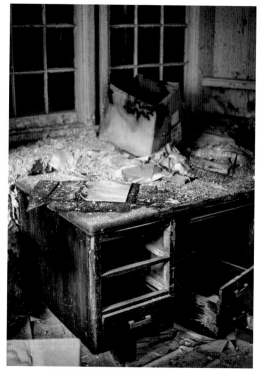

Old desk decomposes in an office.

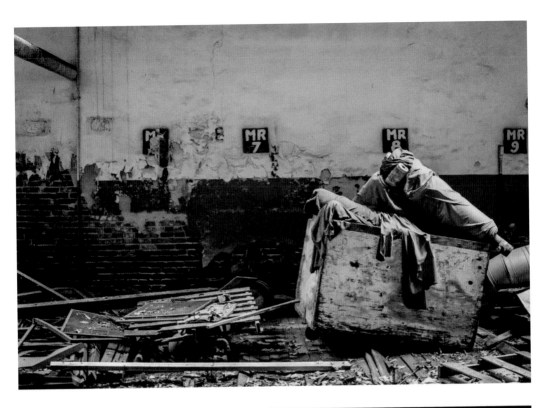

Above: Old fabric cart sides in a production organization line.

Right: Time punch who saw the last employee many years ago.

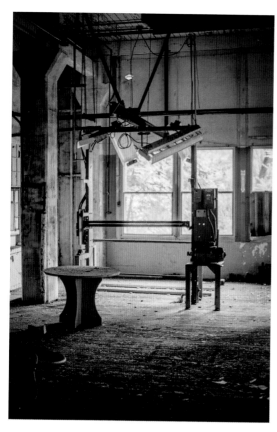

Left: Work station with lights falling.

Below: Fire alarm sign.

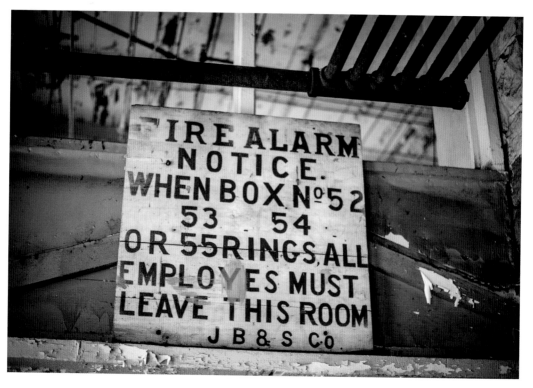

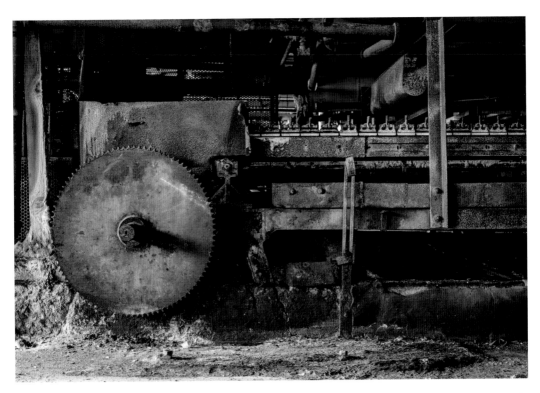

Large mechanism of a conveyor belt.

Fabric stuck in the looms.

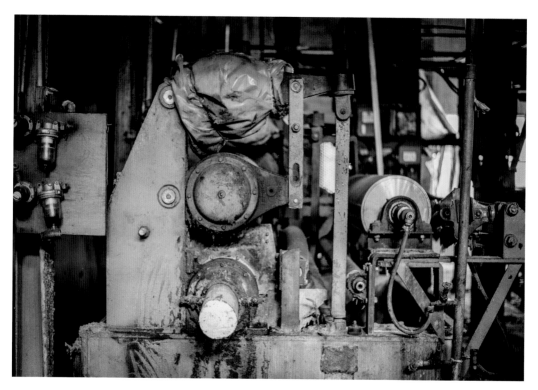

The side of a large machine.

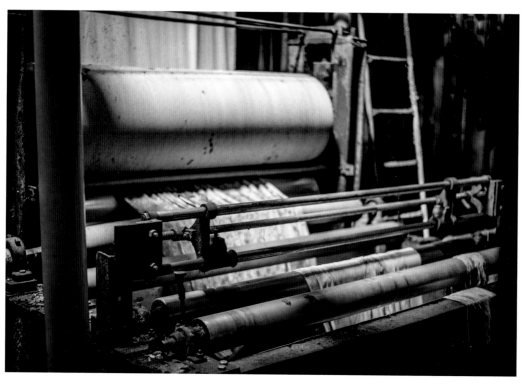

Fabric production machinery.

Back area for servicing the large textile machines.

Another workstation left in pause.

6

QUEEN ANNE BOWLING AND ENTERTAINMENT CENTER

C heapest bowling around. You've got to love the retro vibe from when this place was first built," reads an online review of the bowling alley, and from what I've read, the town very much liked having the old place around. Luisa Carpenter, a Du Pont heiress, bought the property in early 1962 from one Thomas Rogers. The construction began immediately, and the property opened as the Colonial Queen Anne's Bowling Alley. This opening was announced in the *Kent County News* on September 26, 1962, and drew attention and business from there. As a combination of a news story and a promotional piece, the article stated the facilities modern "plush" amenities: the snack bar, wall-to-wall carpeting, air conditioning, PA system, a large parking lot, and, even better, the snack bar was run by local Tastee-Freeze owner Rob Graham. Funnily enough, in that very same paper was an ad for the Chestertown Bowling Center just up the street, which had been the only bowling alley in town. The owner of Chestertown Bowling Center, Allen Harte, must have known what he was up against reading that news article. With a local celebrity and family money running Colonial Queen Anne's Bowling, it was a matter of time before they ran him out of business. In 1965, then Luisa Carpenter did just that, when the Chestertown Bowling Center was foreclosed by the bank.

Later the name changed to Queen Anne Entertainment Center, offering both bowling options, ten-pin, and the Baltimore Maryland founded Duckpin. Duckpin bowling consists of smaller bowling balls, shorter and wider pins, as well as three turns rather than two. A bar, bowling, billiards, and even a mini golf course were also available for entertainment. This was all until the summer of 2016, when the Queen Anne Entertainment Center announced they were closing for the season, but never returned. "The Queen Anne's Bowling Alley and Entertainment Center

on Church Hill Road has closed its doors," reads a headline from the *Kent County News*. The business was last owned by Franklin T. Hogans, Sr., who sadly passed in December 2015 that year. After his passing, the decision was eventually made to close the business. Although scheduled to reopen, Hogans Junior wrote an email to the paper stating, "I am sad to report that the business will not be reopening. This is due to financial considerations. The Estate wishes to thank all the bowlers who have supported the bowling alley over the years." It never returned after the season, as the roadside sign suggested.

Regulars of the entertainment center reacted in such a way that made it obvious that Queen Anne's Entertainment Center was a local institution. A man named Jerry Ferrand from Salisbury said he had been bowling at the center since 1988, when his local duckpin lane closed. He claimed the drive was just as long as the league games, but as a professional duckpin player since 1948, that wasn't going to stop him. Now regulars are dispersing, and many attended a ten-pin alley in Middletown, Delaware. According to Ferrand, there were twelve teams on Tuesday night, and another four on the waiting list, but participation gradually declined. Near the end, there were only eight leagues with three players each, rather than the twelve teams of four he had seen for many years. The junior league was entirely dissolved at this point. People would make the drive from Ocean City, about two hours from the center, as well as from Annapolis and pay the toll over the Bay Bridge. Nancy Miller, a Chestertown native, had been bowling there since they opened in 1962. She said it was a great way to meet people, a social epicenter for the area. "A lot of women from Rock Hall would like to go back to bowling." said Nancy, a Rock Hall resident that attended the three-person teams on Tuesday night, as well as the women's league on Wednesdays. Rock Hall is a nearby town, and the next closest bowling lane from there is in Severn, nearly an hour and a half's drive. But unfortunately for the hopeful, Queen Anne's Entertainment Center will not be returning.

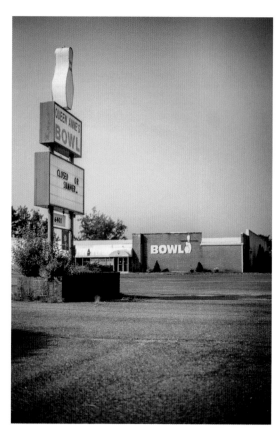

Left: Exterior of the Queen Anne Bowling Center

Below: Bowling lanes frozen in time.

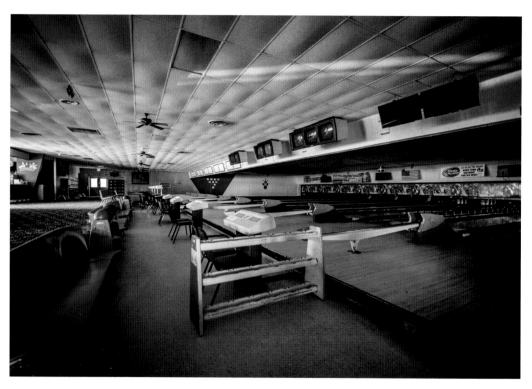

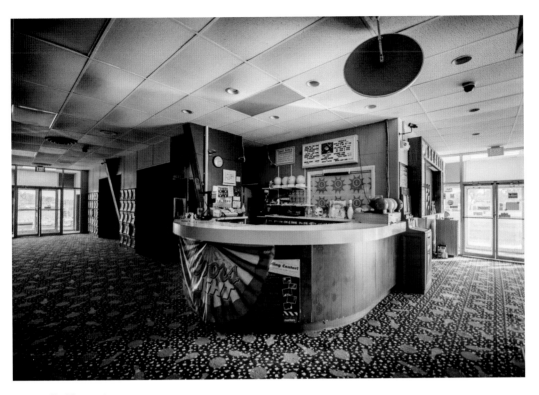

Clerk's counter.

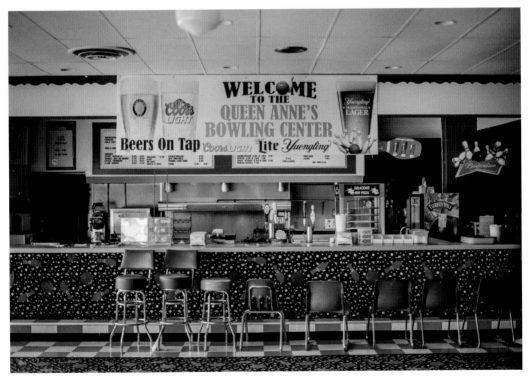

Concessions bar.

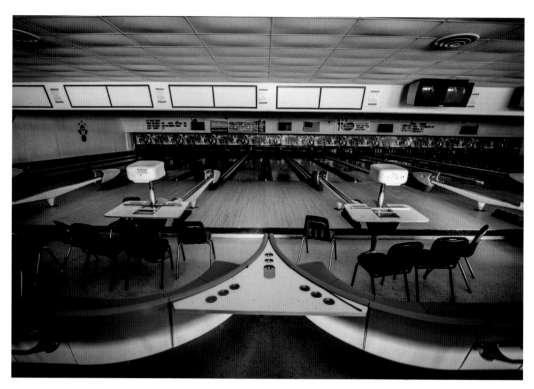

Behind the seating of playing teams.

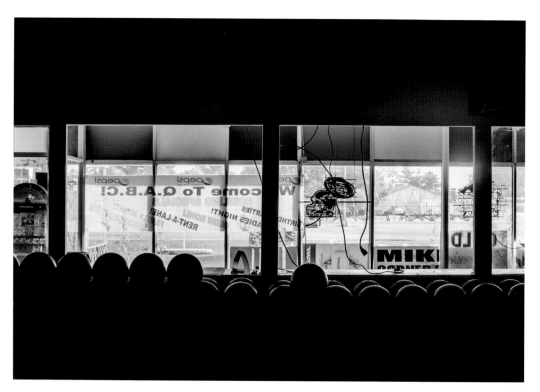

Bowling balls stacked up along racks.

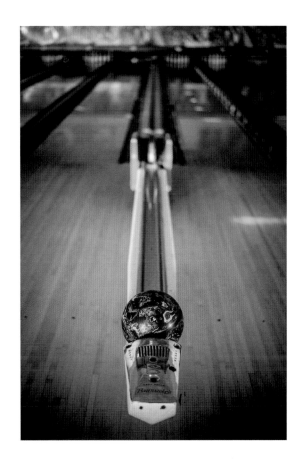

Right: A bowling ball waits for its next play.

Below: Cup holders melting adhesive from years of drink spilling.

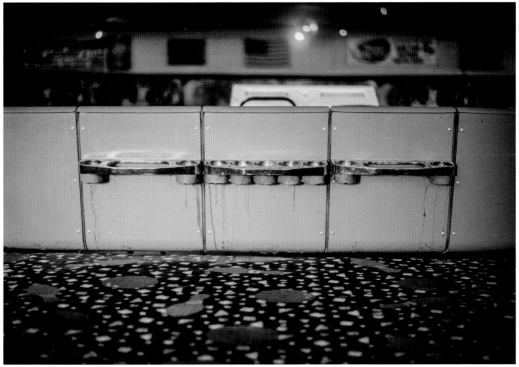

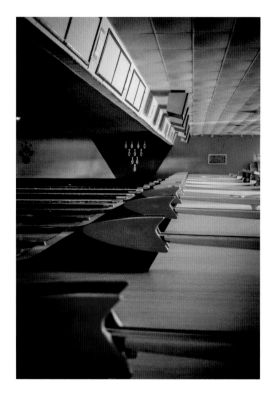

Ball returns lined up along the alleys.

Chair behind counter with shoes in background.

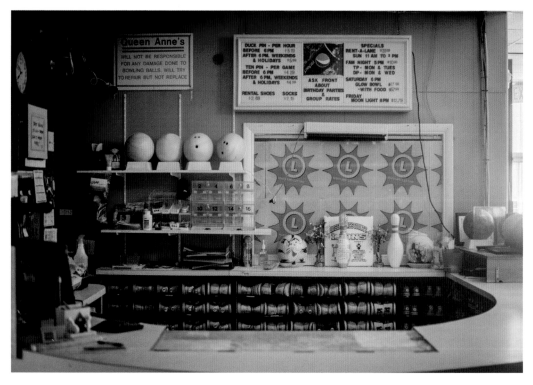

Behind the clerk's counter.

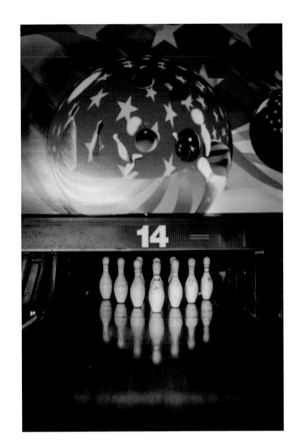

Right: Lane 14 with pins set.

Below: The all-seeing view from the clerk's counter.

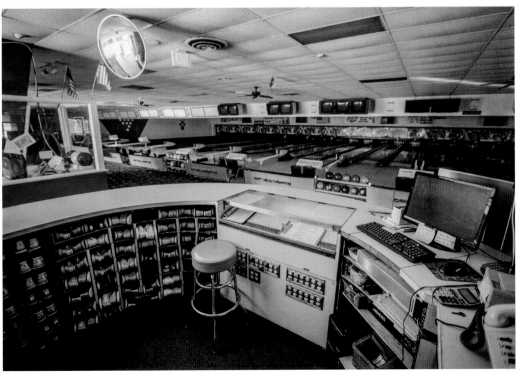

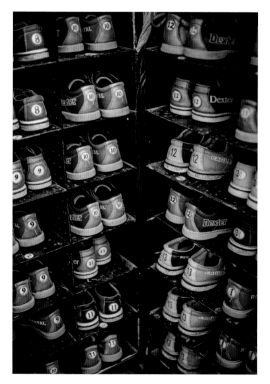

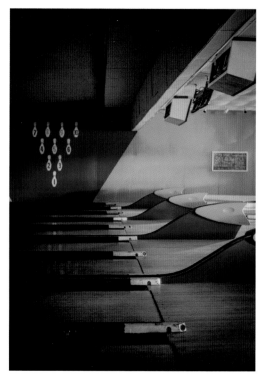

Bowling shoes read to rent.

Bowling alley long way with pin number display.

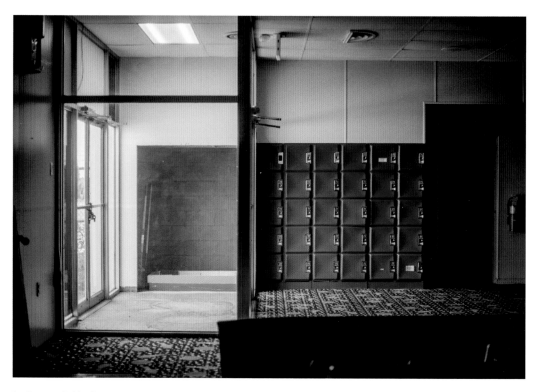

Lockers and side door.

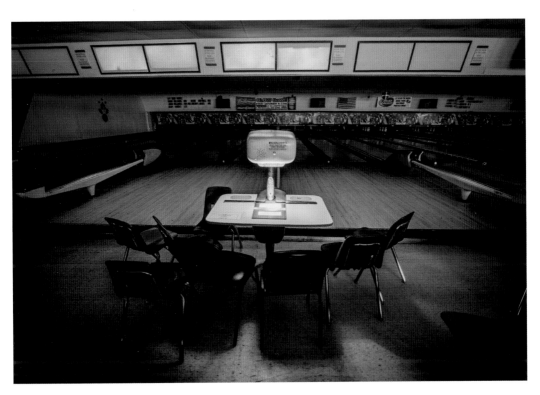

Light's still on at the scoring tables.

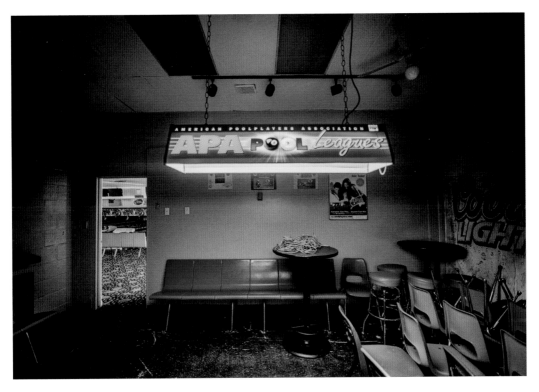

Billiard room.

Maintenance room.

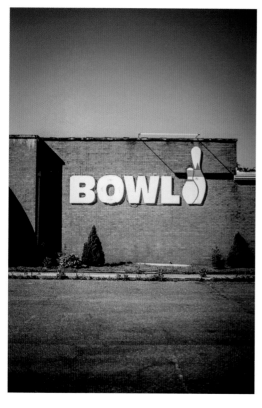

Exterior showing large "Bowl" sign.

7

PAYNTER BUILDING, GOVERNOR BACON MEDICAL CENTER

Sitting on 300 acres of land is the Governor Bacon Medical Center, a medical complex that overtook the property from the historic Fort DuPont. This military installation inhabited the land from the 1870s until 1946, running operations from the civil war and through World War II. The fort's property was given to the state, and this piece of waterfront land just across the Branch Canal from Delaware city became the Governor Bacon Health Center. Throughout the years, the state offered a multitude of different healthcare options out of the facility. Ranging from the care of elderly patients to addicts of drugs and alcohol abuse, this took place in the now reused historic brick barracks and former officers' quarters, known as the Paynter Building today. In 1948, it began to house children, aging from four to sixteen years old, who suffered from mental illness, abuse, neglect, or that were crippled and awaiting foster care.

The history of Governor Bacon Medical Center harbors an unfortunate past. A modern report from a woman named Travalini, who was once a patient at the facility, covers the abuse within the walls of the hospital. Travalini lived at the Governor Bacon Medical Center for a year and a half, arriving when she was fourteen years old; she recalled what is without a doubt inhumane in modern medical and hospital standards. Aides allegedly molested kids with mental handicaps, children were locked up, and there were many other crude acts. Travalini claims that "the children had no voice. They had no home visits, a poor education and every minute of your day was monitored. If you tried to escape, you were locked up." In the year of 1972, the facility began to admit children that had been diagnosed with mental or behavior problems only as care modernized. On august 14, 1983, an article in the *Sunday News Journal* quoted William Powers, the Division of Mental Health's deputy director

of children and youth services: "I heard they used to dump children off at Governor Bacon for almost any reason, but we don't do that now. We've come a long way." At the time, this was true; in the early 70s, the Children's Village at Governor Bacon was forward thinking, both in the name and attitude of the employees. However, in 1984, the state's care for mentally challenged children was spread across smaller centers throughout Delaware. The Children's Village at Governor Bacon Hospital was closed three years later. Thirty-five years the facility was housing children, and many of the kids who were housed there remember the early years and the abuse. A *Delaware Online* article reads from interviews from past patients:

> From February 1963 to August 1964, I was one of them: a 13-year-old abused child with early crippling of my neck, hips and hands caused by lupus, a chronic connective tissue disease.
>
> Touted as a mental health center, I met Dr. Dietz, the staff psychiatrist, once for five minutes. The same day I overheard a social worker say I was sick because I "want attention"—something my father told anyone who would listen. Decades later I read a 1963 report, "Elizabeth has good self-control and is popular with peers. Her attitude towards adults is normal. She mixes well with others. … She is a quiet and normal child."
>
> Passing through the gate I was no longer Billie Elizabeth Toppin; I was another state dependent occupying another state bed: an unknown "other."
>
> "Otherness" is why Brian, 8, ran away, even though it meant spending time in lock-up. There, in a 6-by-8 cell, with only a low cot for comfort, he would bang on the door for food or to use the bathroom. At times, I can still hear the thick door opening and the metal food tray sliding across the floor toward him.
>
> "Otherness" is also why Brenda, 16, wore a smile on her plump face when we marched every Sunday to the movie theater. When Ann Margaret or Frank Sinatra was on the big screen, she longed to hear, "Brenda, your people are here." No one came.
>
> Jimmy, 2, was unable to walk. When an aide spanked him for wetting his bed, I squealed. His grandparents packed him up and out the gate he went.
>
> Janet, 15, wasn't so lucky. Like Brenda, she was a "lifer," having previously lived in The Hospital for the Mentally Retarded at Stockley. Heavy with a lumbering pace, she wore her braces like anchors when she blurted out: "My teacher loves me; we did it." I wanted to hear a false note, but she told me details that convinced me otherwise. I was tempted to scream, but her eyes told me that for once she didn't feel like an "unknown other." She felt wanted. "Janet, if you are late again I will tell the aides where to find you." She lumbered away without comment.

The facility has moved far away from their past and is still operational to this day.

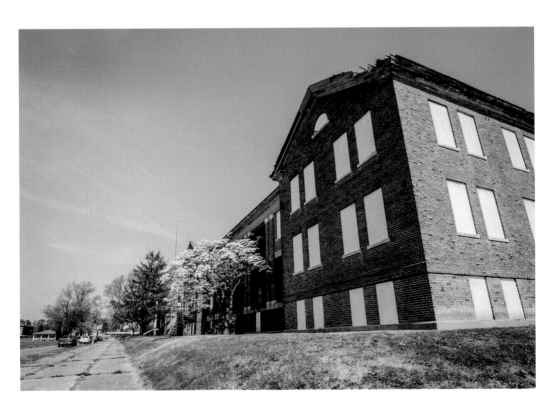

Above: Exterior of the Paynter building.

Right: Wheelchair covered in ribbon.

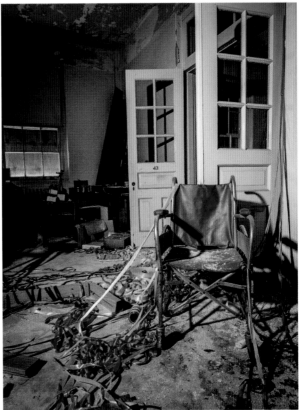

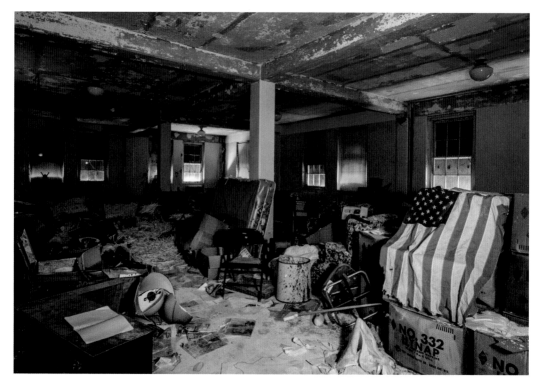

Room filled with storage and a displayed American flag.

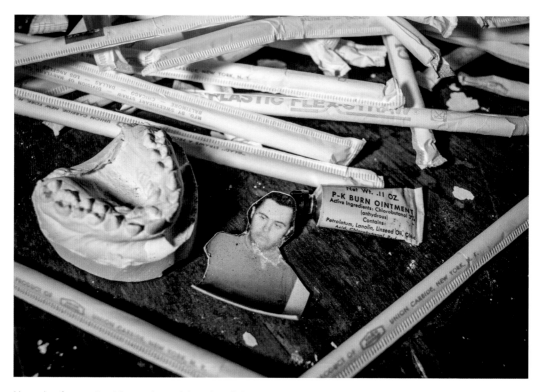

Upper jaw form, cut-out image, burn ointment, and straws.

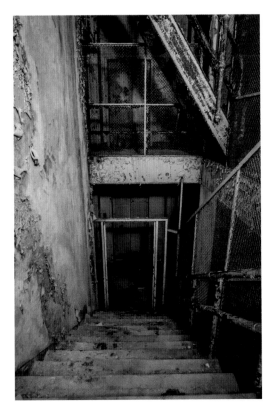

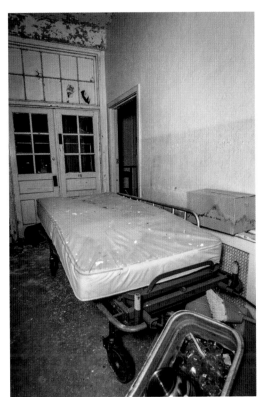

Above left: Looking down a dark caged stairway.

Above right: Patient bed pushed into hallway.

Right: Children's play room with checkered walls.

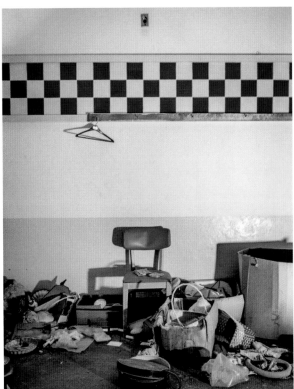

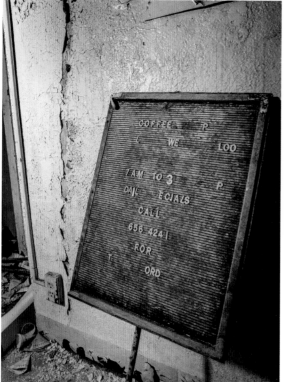

Above: Behind the black checkered wall, these panels were found with tinted glass behind them. This allowed the employees to view the patient's activity without them knowing.

Left: Cafe sign with few letters left.

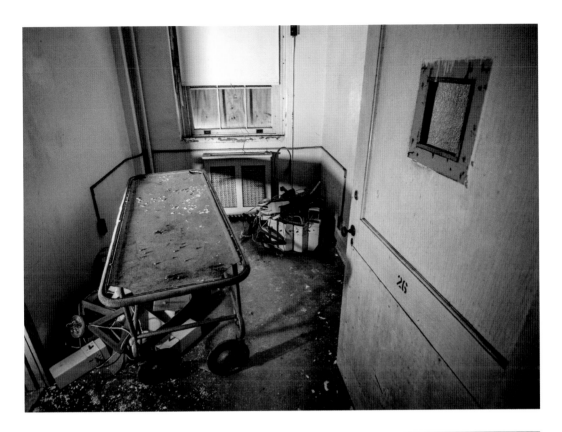

Above: Gurney and other equipment inside a patient room.

Right: Remnants of a CPR dummy.

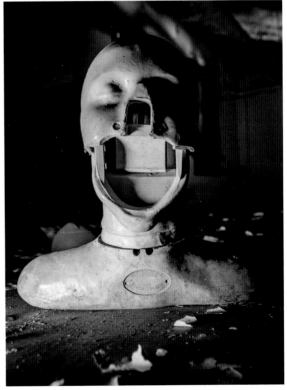

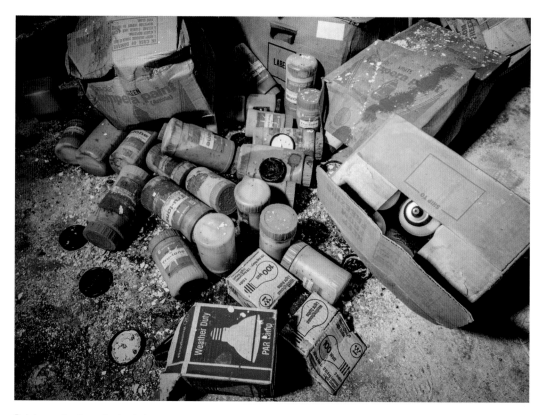

Paint supplies for patient art classes.

Wheelchair left in storage.

Chemistry tubes for blood testing.

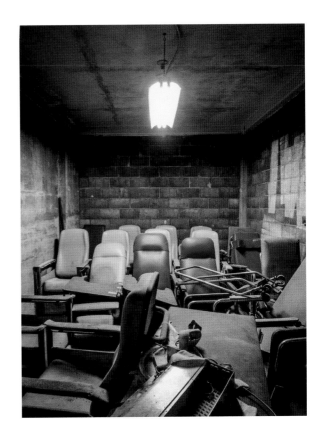

Right: Padded wheelchairs remain in a room that oddly still had power running to it.

Below: Maintenance room.

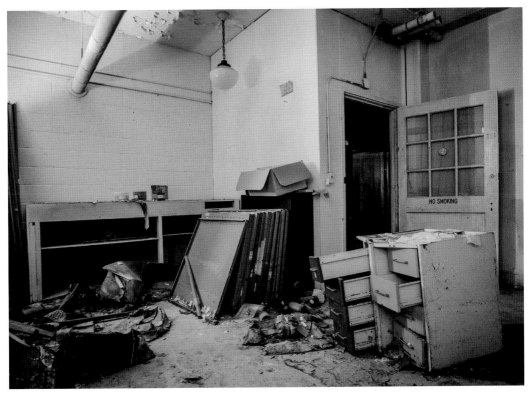

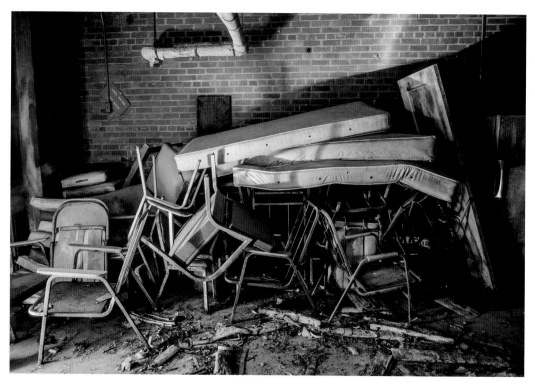

Extra equipment and furniture piled by the back door.

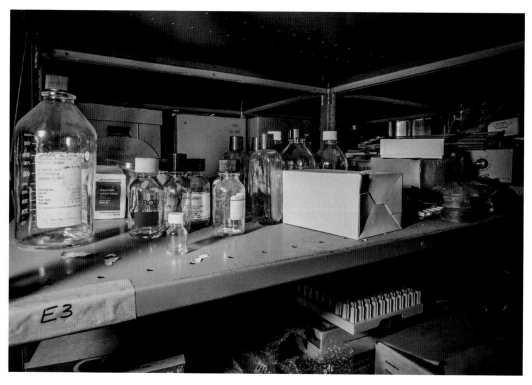

Bottles in storage.

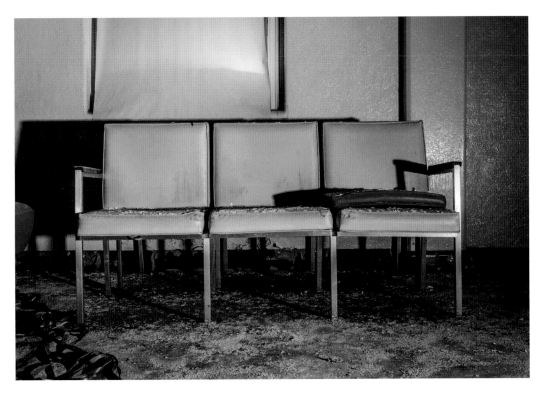

A row of waiting room chairs.

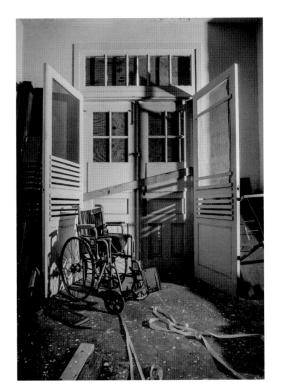

Wheelchair perched by a balcony door.

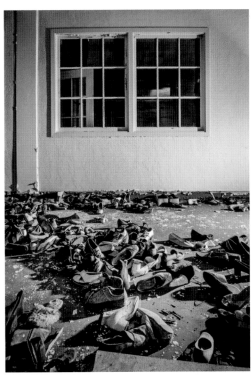

Patient shoes piled in a day room.

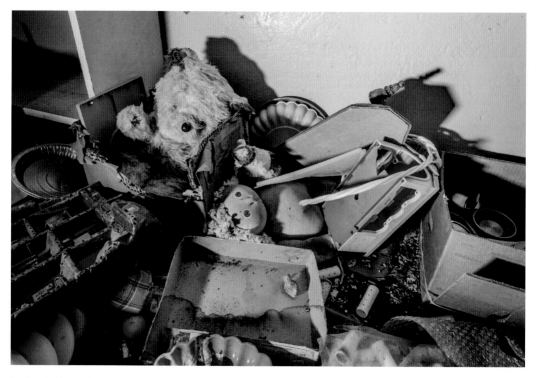

A pile of kids toys in the corner of the checkered room.

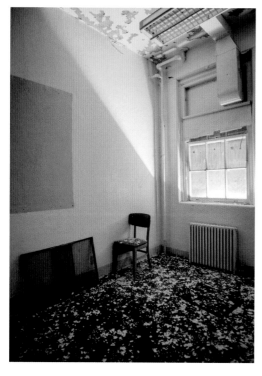

Light bleeds into a room under a small gap from an exterior board.

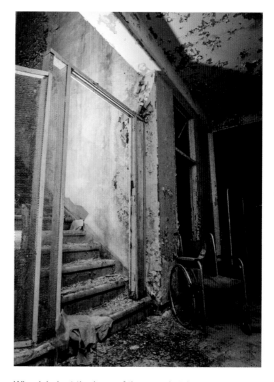

Wheelchair at the base of the caged stairway.

8

PERRYVILLE OUTLET MALL

An active website for the Perryville Outlet Mall states: "Step out of the department stores, come stroll the outdoors and indulge yourself in the ultimate outlet experience." Unfortunately for this website and anyone in hopes of visiting the outlet mall, they have been closed since 2016. Opening in 1990, the outlet mall seems like a great location, right off a main highway in close proximity to Baltimore, Wilmington, and Philadelhpia. It is a wonder it failed. This forty-four-unit mall offered your assumed shopping with big name clothing stores at those warehouse direct prices. Liz Claiborne, Leatherworks, Etienne Aigner, Oshkosh, Geoffrey Beene, Mikasa, Sears, Rue 21, a toy store, book store, Nike, Paper Factory, Bugle Boy, and L.L. Bean rotated through the mall. All were companies that you would assume would bring business no matter the location, especially when the location is convenient. The employees were a bit dumbfounded by the closure; they asked the paper why it closed, as they were getting no answers from the owners.

Town administrator, Denise Breder, said she was between jobs and was hired as a supervisor at the Kitchen Collection store shortly after they opened. In fact, many of the faces who run the town once worked at the Outlet Mall. Town clerk Jackie Sample, who worked in the Outlet Mall's management office, said "I don't know what happened to it. Maybe because people shop online now. Maybe it is the location." She also stated that seeing the mall in recent years was "depressing." Assistant town administrator Cathy McCardell was a cashier and pantyhose stocker at L'eggs, Hanes, and Bali. Office Staffer Amy Yackanech worked at Rue 21 from 1998-1999. Yackanech claimed the nearby toll bridge is what kept people from making the journey.

The mall exchanged hands numerous times over the years and there were many plans devised that may have helped the mall, but none ever came through. The mall's

name is pasted on the town's water tower, which cost $6,000 in rent. Combine that with the $12,000 in annual property taxes, and the town lost out on the mall's failure quite a bit as well.

Ultimately, the toll bridge was causing too much of an impact on traffic to the center and they were unable to attract new stores. The boom of online shopping that is closing brick-and-mortar malls all over had an impact as well. A New York based company, SK Realty, has plans to raze the mall. And in its place, build a warehouse to provide support to the very online shopping that led the mall to closure.

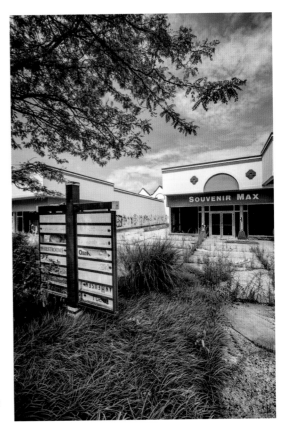

Right: Central area with directory sign.

Below: Interior of a store that has grown rotten with mold.

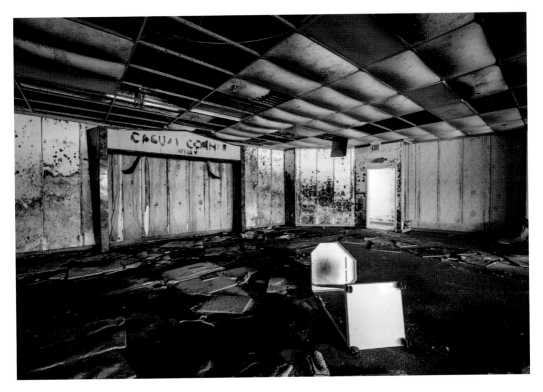

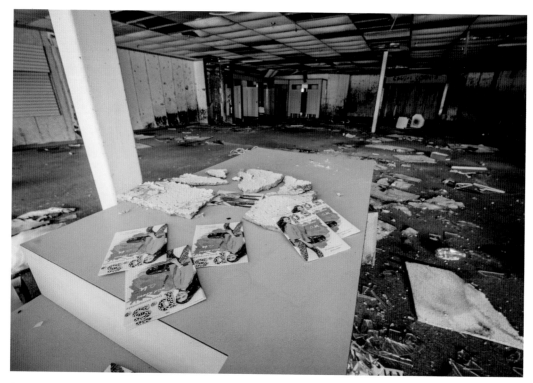

Store ads left on a checkout counter.

Interior area with P.O. boxes.

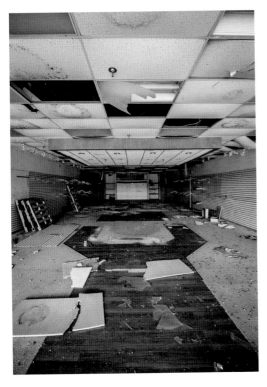
Store left in shambles.

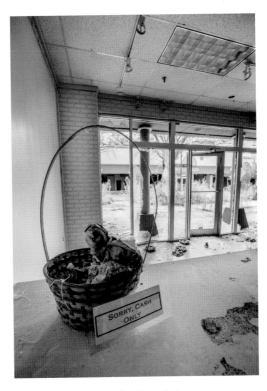
An Easter basket with a "cash only" sign.

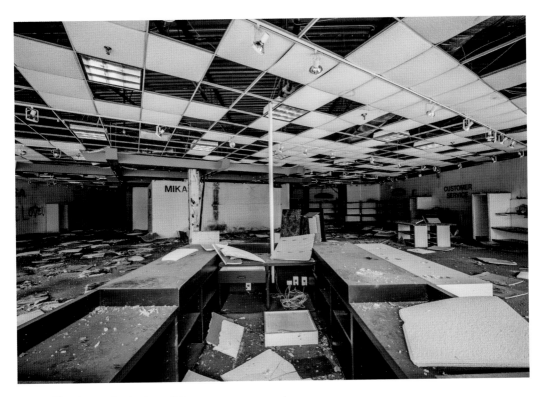
View from a checkout counter.

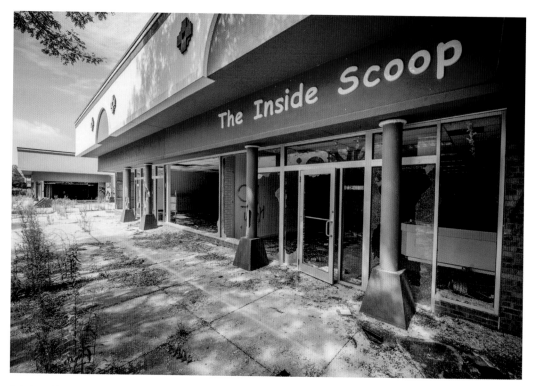

Exterior of ice cream shop.

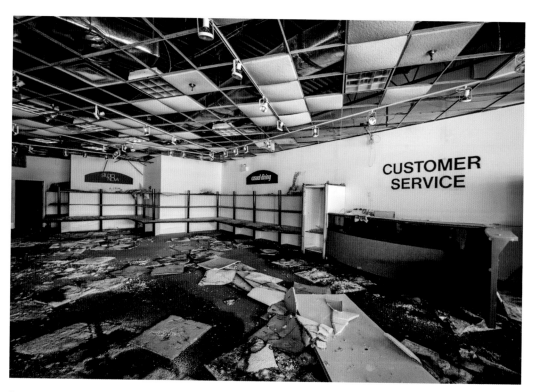

Customer service inside another moldy store.

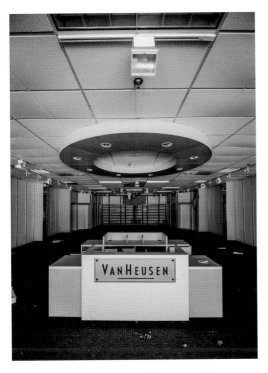

A store which remains in better condition.

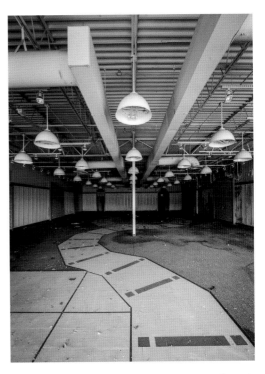

A snaked walkway which once led customers through their store.

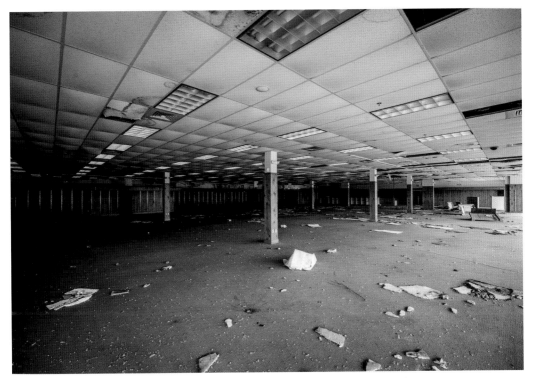

Large, vacant high-end clothing store.

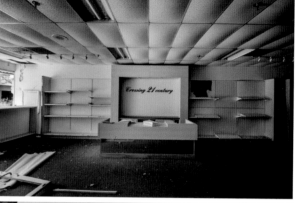

Left: Exterior light with flag.

Above: Another fairly intact checkout counter.

Empty racks of a clothing store.

Above: One of the many entrances to the outlet mall.

Right: The mall sign which would have been seen from the highway.

9

CENTRAL HIGH SCHOOL

Central High School is a large brick building right off the main road that runs north and south through the Delmarva. Just over the Virginia line, this school served a small town of about 3,000 people and the surrounding areas. Its central location, hence the name, is how it was able to house enough students to rationalize constructing a large school in such a small town. Father and son architectural team, J. W. Hudson and J. W. Hudson Jr., built Central High School in two separate phases of construction. One in 1932, and another in 1935. They completed the structure that stands along the highway today with an Art Deco style—this was a common design for American schools in the 1930s. One of their finishing touches is a carved piece of stonework above the northern entrance of twin lamps of knowledge; in the middle of them, you can see the spines of three textbooks.

The first wave of construction cost about $25,000, and after a legal battle that ultimately went to Virginia's Supreme Court, the school board borrowed money from the state literary fund. There were a number of outbuildings in addition to the main school structure that served as extra class space, a vocational school, and a home economics room. Central High School remained a high school until 1984, when the county decided it better fit the needs of the surrounding areas as a middle school.

Eventually, in 2005, Central High School was closed due to school zoning and modernization, and its students were transferred to a newer school campus. The school still stands as an important structure to the town's educational history. After its closure, the property sold to a man named Tucker Robbins, an artist from New York. He bought the property and all the buildings on it for $150,000. Robbins had planned to turn the gymnasium into his furniture workshop, offer concerts in the auditorium, put a restaurant in the building utilizing the kitchen, and lastly finish

the classrooms off as art studio spaces. $50,000 of Robbins' money was used on plans and asbestos removal. Unfortunately, these plans never came to fruition and the school remained vacant and began to fall into disrepair. Robbins disappointedly released the information that it wasn't going to be able to work for his business, and the building went to the market. It appears the building did sell. The school's future is unknown, but the building has been locked up tight with boards and welded doors. Robbins was able to get the school on the National Register of Historic Places before selling the property.

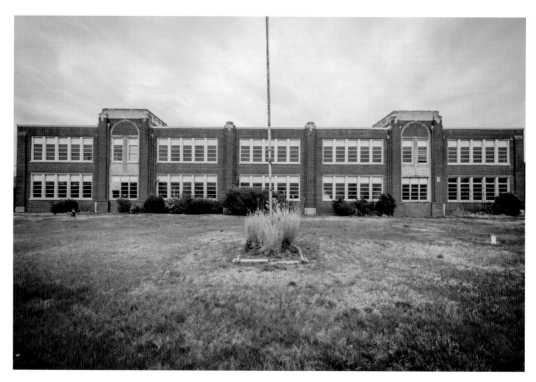

Exterior of the school.

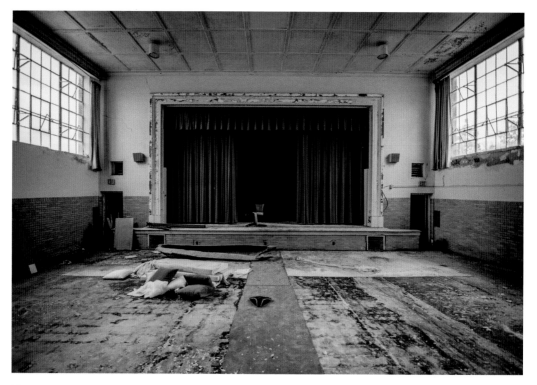

Theater space in the center of the building.

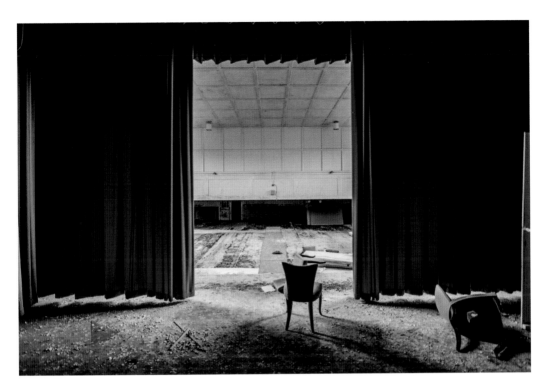

Above: Reverse view of theater space.

Right: The theater seats had been moved into a classroom.

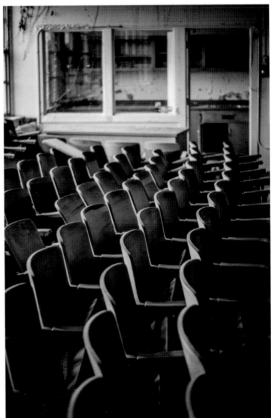

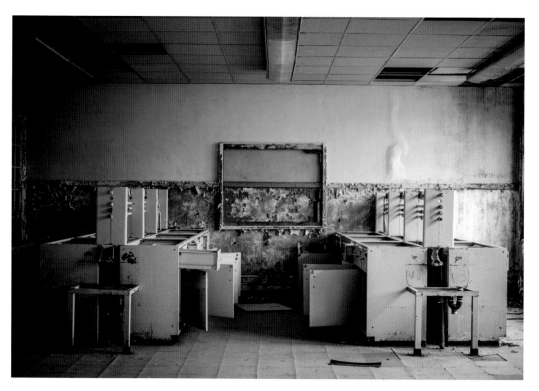

Science class.

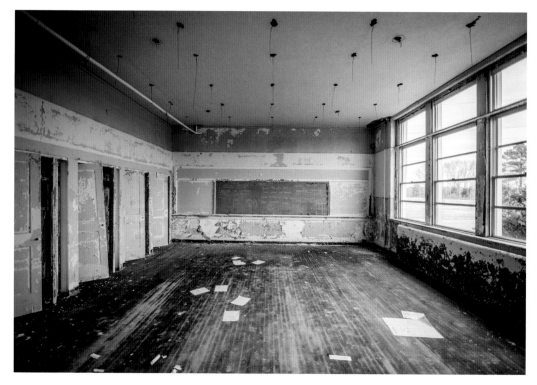

Sparse classroom.

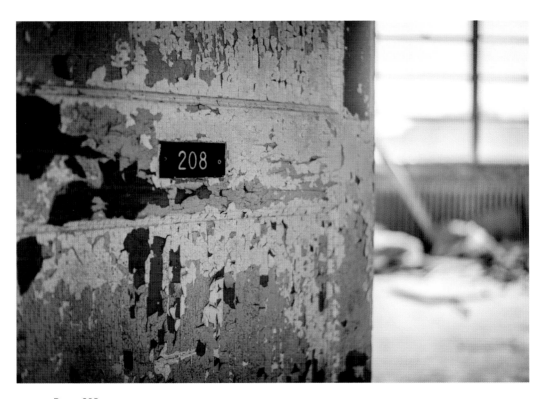

Room 208.

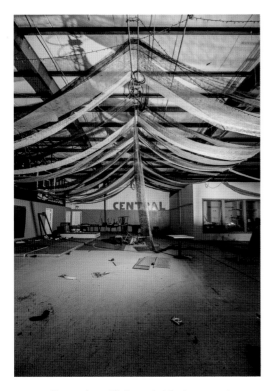

Gymnasium still decorated for homecoming.

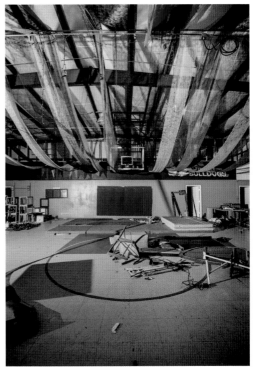

Gymnasium showing basketball hoop.

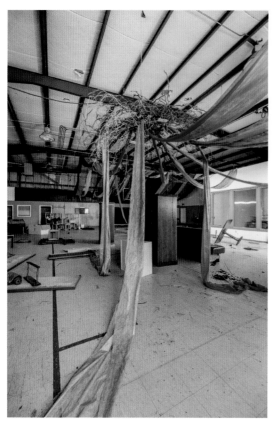

Left: Another angle of the decorated gymnasium.

Below: CHS Homecoming painted on the walls, featuring my shadow.

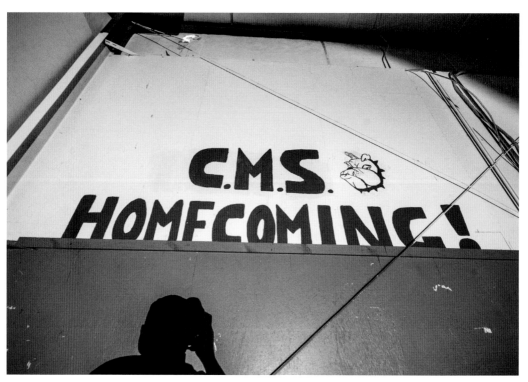

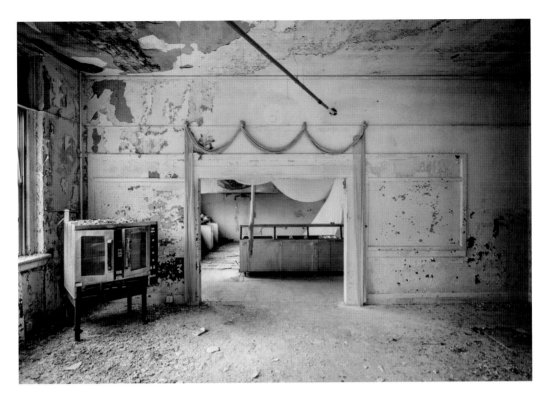

Above: Cafeteria decorated with fabric.

Right: Classroom storage closet doors.

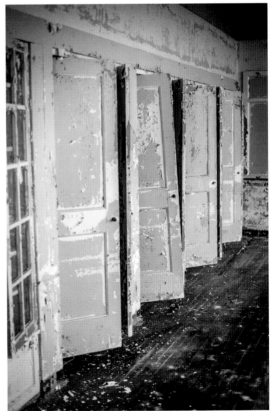

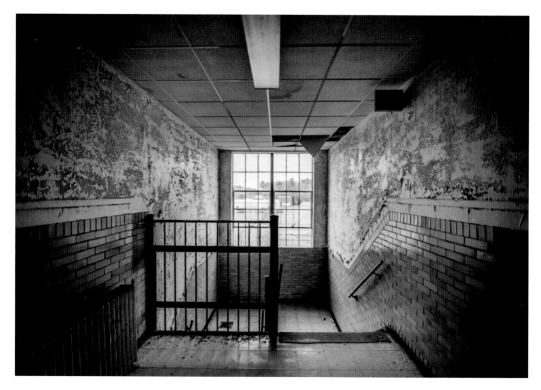

At the top of the south stairway.

Fabric moves from the slight breeze across a chalkboard.

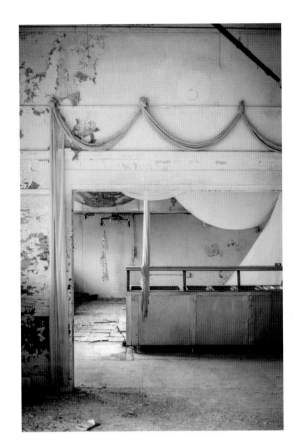

Right: Detail of cafeteria fabric.

Below: A chair partially hidden behind the theater curtain.

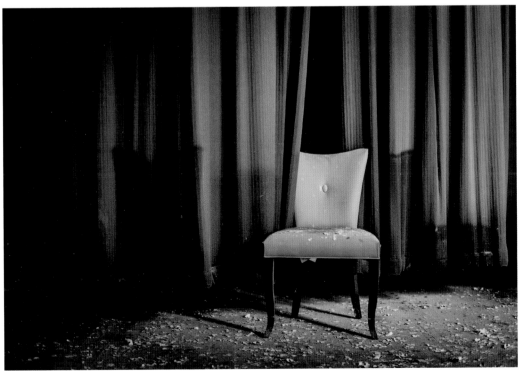

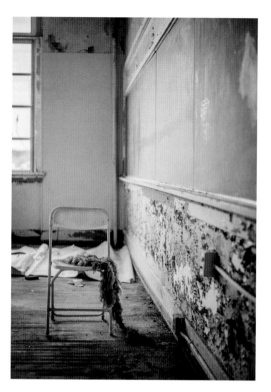

Decoration draped over a folding chair.

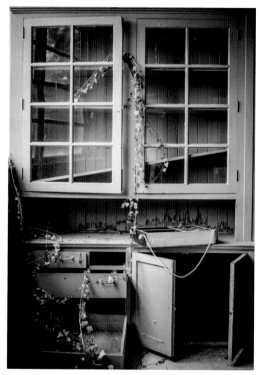

Storage in the art classroom.

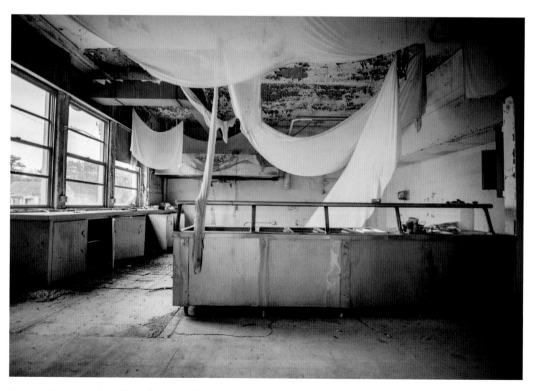

More fabric dangles from the ceiling in the kitchen.

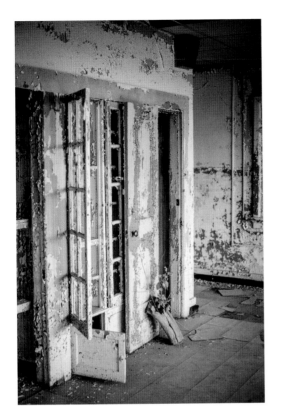

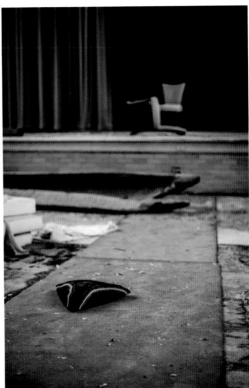

Above left: Classroom storage.

Above right: Long red carpet with pirate hat in the school's theater.

Right: South exterior showing one of the friezes.

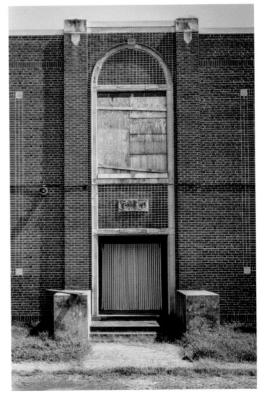

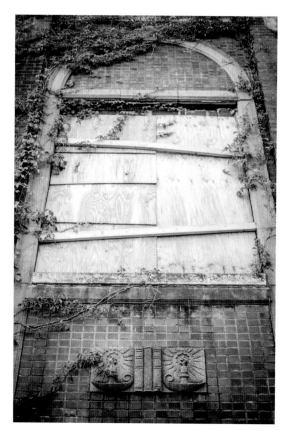

Left: Detail of north frieze.

Below: Outdoor basketball court with school in background.

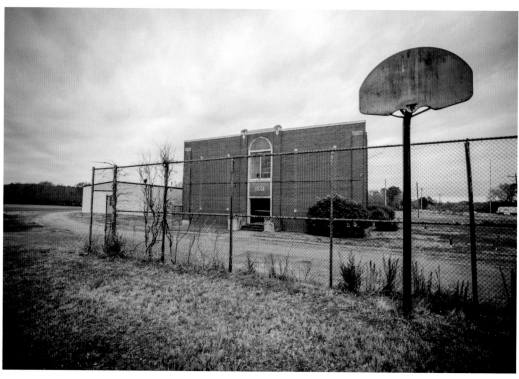

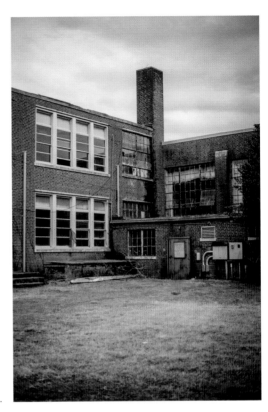

East side of school building.

Small maintenance shed with tree growing beside it.

Above: Dugout and athletic field with concession stand in background.

Left: Close-up of the concession stand.

BIBLIOGRAPHY

TOME SCHOOL

Development Corporation, Bainbridge. "Tome School: Bainbridge-Dev." Bainbridge, 2002, www.bainbridgedevelopment.org/tome-school.

Historical Trust, Maryland. "Maryland's National Register Properties." Maryland Historical Trust, 2018, mht.maryland.gov/nr/NRDetail.aspx?NRID=797.

"Tome School." *Wikipedia*, Wikimedia Foundation, 29 July 2020, en.wikipedia.org/wiki/Tome_School#cite_note-HAER-3.

"United States Naval Training Center, Bainbridge." *Wikipedia*, Wikimedia Foundation, 24 June 2020, en.wikipedia.org/wiki/United_States_Naval_Training_Center,_Bainbridge.

QUEEN ANNE BOWLING

Heck, Peter. "Queen Anne's Bowling Closes." *MyEasternShoreMD*, 24 Aug. 2016, www.myeasternshoremd.com/kent_county_news/news/queen-annes-bowling-closes/article_86947d91-637a-51ab-9135-25c7eda5136f.html.

BANCROFT MILLS

Homeowners Association , Bancroft Mills. "Bancroft Mills History." *Bancroftmills.com*, OAD, www.bancroftmills.com/history.html.

BAINBRIDGE NAVAL CENTER

Sturgill, Erika Quesenbery. "The Past & Future of Bainbridge Naval Training Center." *Cecil Daily*, 30 June 2016, www.cecildaily.com/our_cecil/the-past-future-of-bainbridge-naval-training-center/article_e1e4e364-a4a8-5f67-90c8-8cbb8d823dee.html.

OUTLET MALL

Octoraro Publishing, The Chronicle. "End of Era for Perryville Outlets." *SolancoChronicle.com | The Chronicle*, 2016, www.solancochronicle.com/top-stories/end-of-era-for-perryville-outlets.

EMILY P. BISSELL HOSPITAL

Asylum Projects. "Brandywine Sanatorium." *Brandywine Sanatorium - Asylum Projects*, 15 Aug. 2016, www.asylumprojects.org/index.php/Brandywine_Sanatorium.

Reports, Staff. "State-Run Emily Bissell Hospital near Wilmington to Close Permanently." *Hockessin Community News*, Hockessin Community News, 22 Sept. 2015, www.hockessincommunitynews.com/article/20150922/NEWS/150929937.

Venkatesan, Priya. "Historical Profile, Emily Perkins Bissell." *The Lancet*, Aug. 2014, www.thelancet.com/pdfs/journals/lanres/PIIS2213-2600(14)70174-2.pdf.

CENTRAL HIGH SCHOOL

Cicoira, Linda. "As Building Crumbles, So Do Hopes For Central High - But A Buyer Emerges." *Eastern Shore Post*, 14 Jan. 2019, www.easternshorepost.com/2019/01/14/as-building-crumbles-so-do-hopes-for-central-high-but-a-buyer-emerges/.

Department of Historic Resources, Virginia. "001-5065 Central High School." *DHR Virginia Department of Historic Resources 0015065 Comments*, 4 Apr. 2018, www.dhr.virginia.gov/historic-registers/001-5065/.

Steve. "Class Inaction: Eerie Abandoned Virginia High School." *WebUrbanist*, 14 Apr. 2019, weburbanist.com/2019/04/14/class-inaction-eerie-abandoned-virginia-high-school/.

BLOXOM ELEMENTARY SCHOOL

Nordstrom-Bono, Judy. "Down Home in Bloxom." *Down Home*, Sept. 2006, www.co-opliving.com/coopliving/issues/2006/August%202006/downhome.htm.

GOVERNOR BEACON HOSPITAL

Delaware, The State of. "About Governor Bacon Health Center (GBHC)." *About Governor Bacon Health Center (GBHC) - Delaware Health and Social Services - State of Delaware*, dhss.delaware.gov/dhss/dsaapd/gbhc_about.html.

Travalini, Billie. "Remember Neglected Children of Health Center's Past." *The News Journal*, WIL, 2 July 2014, www.delawareonline.com/story/opinion/contributors/2014/07/02/remember-neglected-children-gov-bacon-health-centers-past/12114097/.

Wilson, Xerxes. "The Lesser-Known History of Fort DuPont." *The News Journal*, The News Journal, 26 Feb. 2017, www.delawareonline.com/story/news/2017/02/25/lesser-known-history-fort-dupont/98354764/.